ANIMATED ADVERTISING

ANIMATED ADVERTISING
200 YEARS OF PREMIUMS, PROMOS, AND POP-UPS

From the Collection of Ellen G. K. Rubin
An exhibition at the Grolier Club
December 1, 2022 – February 11, 2023

Written and compiled by Ellen G. K. Rubin

New York · The Grolier Club · 2022

Edited by George Ong.

This catalog was made possible, in part, by a generous contribution from The Movable Book Society, https://movablebooksociety.org/, a nonprofit organization that provides a forum for artists, booksellers, book producers, collectors, curators, and others to share enthusiasm for, and exchange information about, pop-up and movable books.

FRONT COVER: based on cat. 26.
BACK COVER: Ellen G. K. Rubin's personal logo, designed by Paul Zelinsky, symbolizes involvement in movable books and ephemera for over four decades (see cat. 108 for the original logo).

Photography by Nicole Neehan.
ISBN 978-1-60583-103-9

Dedication

This catalog and exhibition are dedicated to all those collectors, scrapbookers, scholars, librarians, and just plain hoarders, throughout history, who saw the value of ephemeral objects, appreciated, prized, and respected their beauty and worth, and preserved them for us to study and enjoy.

ACKNOWLEDGEMENTS

RECIPE FOR A CATALOG

THE PLAN: Without possibly knowing what lay ahead, namely COVID, I proposed the initial idea for this exhibition to Fern Cohen, chair of the Committee on Members' Exhibitions, who enthused her approval. The dates were to be in 2021. Ha! With date changes came changes to the committee chair, and I greatly benefitted from the support of successors Michael Ryan and Gretchen Adkins.

INGREDIENTS: COVID hastened my choosing the exhibition items and gave me the time in lockdown to create a first draft of the catalog. Without access to libraries, I was fixed to my computer and my own reference library. A shout-out to my son Ben with whom I was quarantined and who served as my in-house tech support. He kept the process on target.

DIRECTIONS: The recipe is the all-important framework for any endeavor. I have Ann Donahue, Chris Loker, and Marie Oedel to thank for their enthusiasm and explicit guidance in what the Grolier Club expects and values in an exhibition catalog. They set the path and kept me on it. And I'm grateful to PJ Mode for sharing his expertise on important issues.

MEASURING AND MIXING: This is the crucial step to refine and combine the ingredients in bringing the catalog to life. I was privileged to have the consummate editor in George Ong. His experience, focus, stick-to-itiveness, guidance, point of view, patience, and sincere caring made this catalog what it is. No comma was too unimportant, and no idea was too big to deter him from refining the text. He gently, and sometimes not so gently, channeled me to a catalog I can be proud of. Several exhibition items are in foreign languages, primarily French. A hearty "Merci!" to Jean-François Vilain for making sure the sometimes antiquated French phraseology read well and correctly.

PRESENTATION: It is the book design artistry of Jerry Kelly that puts the icing on the cake. He takes the text and images and rearranges and decorates them to mold it into a polished book. Jerry's expertise certainly adds a premium quality. Photographing movable paper presents a unique set of challenges which the photographer Nicole Neehan more than ably met. She also produced the video to demonstrate the animation of the movables which helps give the visitor a better understanding of their effectiveness as advertisements.

CHAMPIONS IN THE KITCHEN: The catalog is only one part of the exhibition. Mounting these movable, idiosyncratic, and fragile items takes patience and expertise. For that I have to thank Jennifer Sheehan, Shira Buchsbaum, and their more than capable installers who had to devise unique mounts for them. Because COVID delayed and extended the creation of this exhibition, I needed a cheering squad to rally behind me. For this I thank Eric

Holzenberg, Bruce Crawford, and Nancy Boehm and the Locktail group, Caroline Schimmel, Regan Kladstrup, Nancy Rosin, Jean Stephenson, Jean-François Vilain, Mary Schlosser, Bill Buice, Natalie and John Blaney, Gretchen Adkins, Jennifer Sheehan, and Fern Cohen. Jessica DuLong, as family, friend, and fellow writer, offered sound and caring advice, as did my dearest friend, and partner in bookish things, Myrna Shinbaum. Thanks to the Movable Book Society for their financial and enthusiastic support of this exhibition. And finally, apologies and thanks to all those, named and un-named, who patiently listened to my complaints. I hope all will enjoy partaking in this delicious result.

Contents

A Passion for Pop-ups: 40 Years of WOW!*

The rush of joy comes back to me when I think of that evening, probably 40 years ago, when I first opened *The Pop-up Book of Trucks* (Random House, 1974) to "read" to my son, Andrew. (This book happened to have no text.) Reading had long been a part of our bedtime ritual, but this would be a new experience for both of us, my first of many with the "WOW!" factor. I had found this pop-up book at a local bookstore—plentiful then—drawn to it for its colorful illustrations of all manner of vehicles, illustrations that were, amazingly, almost life-like. We pulled a tab together to make the fire-engine ladder rise, turned a wheel to make the cement mixer grind, and opened the flaps to see inside the moving van. Best of all was grabbing the little tabs on the car carrier and making the cars slide on and off the ramps. I think I was more excited than Andrew interacting with the book, recreating the actions inherent in each type of vehicle. The paper engineer, in devising these ingenious mechanicals, had allowed us to actually become the energy behind the vehicles' movements.

Until that moment, I had never known of these fabulous and interactive books called "pop-ups." Always a reader myself, it had been an added joy for me to use my hands along with my imagination. I remember in the early grades loving the monthly magazine, *Humpty Dumpty*, filled not only with stories but also with cut-outs and paper toys to assemble. When the other girls moved on to *Children's Digest*, with more mature stories but no need for scissors and glue, I balked and insisted I keep my *Humpty Dumpty* subscription, withstanding the derision they heaped upon me. I could read more sophisticated stories, I reasoned, in the books I borrowed from the local library. An interactive experience was only to be found in *Humpty Dumpty*.

So there I was, now an adult, responding again to the need for reader involvement in a book. Thus began my adventure as a collector of pop-up and movable books. My initial thought had been to concentrate on acquiring pop-ups of children's classics and fairy tales, like *The Secret Garden* and *Cinderella*, and those on scientific subjects (since science has been my interest and occupation), like *The Human Body* and *The Facts of Life*. I was especially enthralled with the science books and realized that the use of dimensional paper allowed them to be unique teaching tools. I thought, "A picture may be worth a thousand words, but a pop-up is worth a million." By actually manipulating the paper I could "make" the sperm reach the egg and even do a "dissection" of the human body by lifting the flaps, exposing layers of muscles, bones, and internal organs.

But my fledgling collecting habits changed in 1988. While a student at Yale Medical School (in the Physician Associate Program), I visited an exhibition called *Eccentric Books,* curated by Gay Walker, at Yale's Sterling Library. Over 125 books were displayed, some dating back to the fifteenth century, all with movable paper components. I had no idea these books had such a long history. Even the simply printed catalog boasted pop-ups on each of the endpapers. (Naïve to collecting, I only bought one—at five dollars.)

At the exhibition, I discovered the "WOW!" factor, awed by the inventive quality of the early use of paper engineering. I began to collect with a new eye and appreciation. After graduation, I sought out book fairs, tag sales, and flea markets in search of pop-up books. I was on eBay when it was in its infancy.

In 1994, I became one of the first members of the Movable Book Society, established as a forum for collectors like myself. The society published a newsletter, *Movable Stationery*, and I began to write articles about my escapades in collecting and what I was learning about pop-up and movable books. The society brought me into contact with paper engineers, book artists, librarians, publishers, and packagers, especially at our biennial conferences, where experts in their various fields enlightened us. Many collectors also showcased their prized objects. My whole book world was expanding.

While I focused on movable books at the many book shows I attended, I wouldn't ignore the ephemera. Learning about them and becoming a member of the Ephemera Society brought me

greater understanding of these often-unique items. Alas, in the beginning years of my cataloging, I didn't list them. Much information about them is lost to me now.

But looking at the ephemera collection, stored loosely by subject in 3-ring binders, I began to realize that many of these "made to be discarded" postcards and advertisements displayed more complex mechanicals than many of my books. Since level of complexity is tied to cost of production, I started paying more attention to ephemera acquisition. I began researching the companies, products, and even the patents. I also appreciated that these ephemera were even available or were being exhibited because someone valued them, either for the subject matter or, in the case of interactive ones, their uniqueness. Collectors, scrapbookers, even hoarders, took these fragile objects and gave them protection from discard. We owe them a great debt for preserving these truly historical materials.

Interacting with a pop-up or movable book or a piece of ephemera is an adventure. I thrill to the way paper engineers will enhance a story, a product, or an idea by imbuing the subject with movement. I am drawn into an imaginative world and am expected to be a participant. I see the paper engineer as a puppeteer who hands the strings to us, the readers. Perhaps these books are the dollhouse I never had as a child. The more I can play with the them, the happier I am. An object will find its way into my collection if it passes "The Smile Test" and ranks high in the "WOW!" factor.

I delight in finding new movables with ingenious paper engineering or on subjects one wouldn't think would lend itself to being dimensional, like *The Pop-up Book of Phobias*, a book illustrating strong emotions. I don't, however, enjoy pop-ups as much if their presence is gratuitous—there for their own sake—and don't enhance the story.

Advertisements with dimensional elements are intended to get your attention, get you to interact with them and thus, be retained in your memory. These movable advertisements are found almost anywhere like professional conferences, mercantile establishments, magazines, and museums. I find them in clothing stores, plant nurseries, and even at my car mechanic's showroom. Some are mailed right to your door. Historical ads are offered at book fairs and on-line auctions.

I'm always trying to move the timeline of my collection backward, searching for earlier and earlier examples of the use of movable paper. My oldest book is a 1547 edition of Sacrobosco's *De Sphaera*, an astronomy text with volvelles. Finding earlier examples with movable elements is a daunting task due both to their rarity and cost. My collection of over 11,000 items contains text in 41 languages.

I have been lucky in my pop-up world, like the coincidence of my being in New Haven at the time of the *Eccentric Books* exhibition. Lucky too, that I have been able "to shop and share" and have mounted exhibitions like this one, *Animated Advertising: 200 Years of Premiums, Promos, and Pop-ups*.

It is my hope that the books and ephemeral advertising chosen for this exhibition will demonstrate the use of dimensional and interactive paper elements to achieve the promotion of products, art, and events. I have sought to include items representing different kinds of mechanical devices while giving examples in many different languages and products. And in order to show the broadest examples in this exhibition, some objects could have easily been placed in more than one category. It has been my intention to emphasize the history of movable paper for advertising, the role of interactivity in achieving those ends, and the daring of paper engineers in their use of dimensional paper in ephemeral objects. I will have achieved my goals overall if you, the visitor, come away from this exhibition saying, "WOW!"

<div align="right">

ELLEN G. K. RUBIN
June 2022
www.popuplady.com

</div>

* Adapted from the essay "A Passion for Pop-ups: 20 Years of Wow!," written for the exhibition *Ideas in Motion: The History of Pop-up and Movable Books and Ephemera from the Collection of Ellen G. K. Rubin*, April 11–30, 2005 at the Sojourner Truth Library, State University of New York, New Paltz.

Introduction

Whether trying to convince someone to see your way of thinking or actually marketing a product to a targeted audience, we are all salespeople in one context or another. For many years, I have been collecting promotional products and premiums with movable paper elements; only a subset of these are actual pop-ups, three-dimensional and standing up off the page. *Animated Advertising* features many types of movable advertisements, with a smorgasbord of different paper mechanisms. It will be of interest to visitors and readers here to be aware that the use of movable paper began, as far as we know, in the twelfth century. Even now, as then, all interactive paper elements are hand assembled.

According to Charles Breskin in the April 1946 issue of *Scientific American*, "Premiums are products offered in return for coupons, box tops, letters to advertisers, a trip to a store, services rendered, special purchases, or any of these plus a small amount of cash. They are an inducement to buy. It involves an effort as well as an outlay on the part of the customer."[1] The use of coupons or trading stamps to redeem in exchange for merchandise from a vendor was first recorded in 1793. A Sudbury, New Hampshire merchant gave out copper tokens to buyers that could be redeemed for new goods.[2]

Promos, short for "promotional items" are, according to Breskin, "advertising specialties . . . straight goodwill-promising gifts, requiring no effort or outlay from the customer."[3] What all the examples shown in this exhibition have in common is the intent to get the consumer to buy, appreciate, or learn about some aspect of a product, idea, action, or amusement. And all examples in the exhibition are embellished with an interactive paper feature and most, if not all are ephemeral, made to be discarded. Considering the age and purpose of many of them, I am always astounded that they still survive today because a recipient valued them enough to keep. And, since many are decades old, subsequent generations agreed and kept them as well.

A BRIEF HISTORY OF EARLY ADVERTISING

But let's get into the heart of this exhibition. Hard to believe but the first known piece of paper advertising was seen during the Song Dynasty (960–1280 AD) in China. It was there, where paper money was first used, that Linan Liu advertised his Fine Needle Shop saying, "We buy high quality steel rods and make fine quality needles, to be ready for use at home in no time."[4] It is quite an understatement to say that the printing of the Gutenberg Bible (ca. 1455) was a gamechanger globally. The use of movable metal type allowed for advertisements, especially broadsides, to be printed in quantities required by advertisers who wished to spread the word of their wares far and wide.

In 1476, William Caxton advertised his book, *Sarum Ordinal*, a manual for priests, by printing paper broadside ads and posting them on church doors. Caxton anticipated a response to our modern-day warning "Post no bills" with one of his own, *Supplicio stet cedula*, "Please do not remove this handbill."[5] The ad asked interested parties to come to Caxton's Westminster Abbey shop to buy the book. Despite how we may look back on Caxton's success, he of course had no assurances his book would attract buyers.[6]

With a mostly illiterate population, sign boards, especially of trades, were used in front of shops with representative graphics to alert prospective clients to what was being offered inside. The word "advertisement" is derived from the Anglo-French word, *advertisen,* meaning to notify or inform.

Newspapers appeared during the sixteenth century with weeklies printed first in Venice. A newly graduated medical doctor, Théophraste Renaudot (1586–1653), is credited with creating *La Gazette de France*, the first French newspaper, in 1631. Considered too young to practice medicine, instead, he cared for the underprivileged by opening a center in Paris on the Île de la Cité that listed jobs for the homeless and downtrodden. These job listings quickly progressed into advertisements for goods and services. Creating *La Gazette* enabled him to better publicize these job openings through the use of ads. He is thus also considered the inventor of the personal ad.[7]

The Industrial Revolution created the tsunami upon which so many innovations rode, like printing, publishing, manufacturing, all amid social changes. Farmers left their land for urban centers, creating a demand for household products in large numbers. No longer living the self-sufficient rural life—growing their own food and making their own clothes—they became consumers. Competition to provide products and services primed the landscape for advertising. Furthermore, technological advances mandated that workers be able to read directions and manuals. Universal education became a priority and was legislated. This newly literate populace could read newspapers and magazines, exposing them to promotional ads. Buy me! Use me!

William Taylor of Taylor & Newton is considered the first advertising agent in England, when in 1786, he began to offer advertising services to printers who were publishing their own newspapers.[8] In 1842, Volney B. Palmer opened the first American advertising agency in Philadelphia. He served as an ad agent for newspapers all over the country. Palmer's agency was acquired in 1877 by Francis W. Ayer, becoming N. W. Ayer & Son. Ayer further revolutionized the advertising agency business by having a full-time copywriter and an art department. It later produced some of the most recognizable ad campaigns still used today, like De Beers's "A diamond is forever," and Morton Salt's "When it rains it pours," among others. Palmer and Ayer changed the way business is conducted in the United States.[9,10]

There is a Confucian saying, "Tell me and I may forget. Show me and I may not remember. Involve me and I will understand and learn." Involvement makes the manipulator of dimensional objects invested in the message and promotes understanding and memory. The financial bottom line is what almost all advertising is about. How can an advertisement get a population to buy, attend, understand, or promote a product or an event? These promotions take many forms; some use "dimensional graphics," that is, 3-D pop-ups. The object of promoting a product by using an interactive component is to grab the recipient's attention and say, "Look at me!" William Smith, in his 1863 book, *Advertise: How? When? Where?* says, "anything that strikes the eye as being *odd* or *strange* attracts attention and gets talked about. What more can any advertiser wish for?"[11] The mid-nineteenth century saw a plethora of almanacs, trade cards, calendars, greeting cards, and medical advice being printed on paper or cardstock and distributed by salespeople and store proprietors, all with the intent of having the recipient retain this ephemeral object for repeated future reference or amusement.[12]

Mike Maguire, CEO of Structural Graphics, a Connecticut company specializing in dimensional advertising, has said the three targets of this form of advertising are "Attention. Interaction. Involvement." According to Maguire, movable paper ads "outperform" flat ads. And considering any movable ad will be more costly to produce than a flat one, performance is the goal as well as a necessity.[13]

TRADE CARDS

Forward strides in printing were the underlying impetus that enabled progress in all spheres of advertising. Lithography, developed in the 1790s by Johann Alois Senefelder, was a process based on drawing on limestone with a wax crayon that attracts ink. Later, with chromolithography, different colors could be laid down sequentially on separate limestone blocks, giving the print rich and shaded graphics and text. Bypassing the more labor-intensive woodcut, etching, and hand coloring processes, multiples of prints could be turned out more easily, and more importantly, cheaply in great numbers. Germany became the center for chromolithographic printing and remained so until the First World War. Raphael Tuck brought the process to England, and Louis Prang, who created the first American greeting card, perfected the technique in the United States.[14]

With a literate receptive populace, tradespeople could cheaply print advertisements for their

goods and services and add artistic and eye-catching graphics. Name recognition was the object of trade cards and a push for "branding" took hold.[15] It's been shown that children are especially cognizant of logos and learn to respond to them before they can read.[16] Even products not usually used by children, like tobacco, had advertising campaigns that appealed to youth.

The advent of movable trade cards highlighted brand names, making businesses more memorable. Many consumers saved the cards in scrapbooks, turning them into collectibles. Scrapbooking, the rage in Victorian times, fired up the production of advertising cards, which were often produced in sets. Many trade cards in my collection bear glue scars on their reverse sides, signaling their removal from scrapbooks. The cards were placed on store counter tops, free for the taking, in packages, and in the products themselves.[17] The use of trade cards waned during the latter part of the nineteenth century as newspapers and magazines were in their ascendancy.[18] Still they were the first "premiums" to be issued in vast numbers.

Another consequence of the Industrial Revolution was the rise of the middle class. With it came literacy, disposable incomes, the recognition of childhood and, with the acquisition of leisure time, the onset of shopping as a pastime. Shopping and changes in fashion led consumers to seek new products to build their social status, namely "keeping up with the Joneses."

Topping the list by far in my collection, both in terms of the number of items and complexity, are the trade cards of the Au Bon Marché department store in Paris, founded by Aristede Boucicaut (1810–77). This creative entrepreneur broke the mold for retailing with the firsts he brought to his establishment: set pricing and no bargaining, customer access to shelved goods, home delivery, credit, free holiday events, and the distribution of cards with Au Bon Marché advertising on the reverse side. He and his wife, Marguerite (1816–87), were forward thinking, e.g., the store maintained an on-site cafeteria and a hospital to provide medical care to its workers. His employees were given shares in the profits and a voice in policy changes. Following their deaths, the employees took over running the company. These were "managerial revolutions."[19]

It was Boucicaut's brilliant idea, starting in 1850, to give out free chromolithographed cards, printed in sets. Since children did not go to school on Thursdays in Paris, they begged their mothers to take them to Au Bon Marché for the next card in the set they were collecting. (We collectors understand the compulsion to complete a set.) From 1895 to 1914, Au Bon Marché distributed 50 million chromos, as they were called in Europe, each with a circulation of between 100 and 400,000 copies![20] These cards were spectacularly illustrated and were among the best chromos to be distributed. Boucicaut used accomplished artists to produce the graphics covering a wide variety of subjects, places, and themes.

True to competition, other department stores followed suit issuing illustrated cards with their name and logo. Companies that manufactured or sold products like chocolate, "healthy" foods, medicines, and household and commercial tools also produced these cards. Chocolat Guérin-Boutron, for example, printed a very large series of transformation cards of Jean de la Fontaine's fables. In my collection, the printers J. E. Goosens and Leopold Verger, both of Paris, are well represented.

Needless to say, my collection restricts itself to those cards that have movable elements. I'm aware of the thousands of others without them. It continues to surprise and delight me that some of the most complex mechanisms, those that are the most expensive to print and hand assemble, were given out for free. The large variety of these cards is reflected in the amount of catalog and shelf space I've given to them in the exhibition. Don't for a moment forget that some of these cards are almost 200 years old and have survived because recipients valued their beauty and uniqueness as much as I have. Alas, I have only been able to show the exhibition attendee but a small example of the Au Bon Marché cards and others.

HIGHLIGHTS OF THE COLLECTION

PHARMACEUTICALS

I've observed that the industry with the largest budget will produce the most movable advertisements in terms of quantity and complexity. A big budget is a necessity since all dimensional paper products, whether they are pop-up books or flat movable items, are assembled by hand. The highest cost is labor. In fact, dimensional paper facilities will follow the cheapest labor market around the world.

The five industries I've found that generated the most prolific and complex ads are pharmaceuticals, alcoholic beverages, tobacco, food, and autos/auto-related. Let's start with pharmaceuticals. Having worked in the medical field and attended medical conferences, it served my burgeoning collection well to walk around the promotional sales presentations and scoop up the movable ads for new medicines and medical equipment. These medical-related premiums were given to a targeted audience for the greatest impact.

Quackery, the peddling of nostrums, has been around for centuries. But, at the onset of the Industrial Revolution, people were concentrated in urban centers, precipitating more illnesses. More medicines were needed to be created and offered. Pharmaceutical advertising was born at this juncture. As printing proliferated in the West, books, as well as newspapers, advertised these quack medicines. The paid advertisements helped defray the cost of the printing. The nineteenth century in particular was filled with medical quackery, drugs and medicines claiming to cure a vast array of ailments. Known as snake oil or patent medicines, these nostrums were offered in great quantity by itinerant salespeople who traveled the world.

The oldest pharmaceutical movable in my collection was produced in 1824 (cat. 1). Originally part of a pharmacopeia, it is a volvelle used by doctors to calculate dosages of medicines. A volvelle—from the Latin verb *volvere*, to turn—is a paper or cardstock wheel placed over a printed base page and affixed in the center with a linen thread or fastener. The wheel may have die-cut holes or pointers allowing information on the base page to be accessed and collated. This mechanism dates back to the thirteenth century!

As printing techniques advanced and newspapers became more readily available, many more products could be advertised. There were few, if any, regulatory bodies to govern the claims that quacks made. The proliferation in Britain of newsprint after 1750 allowed for one quarter to one third of printed space to be used for the advertising of goods. And medical ads were quite prominent there.

The nineteenth century brought an even greater expansion in printing techniques. Color was added with the advent of chromolithography, allowing for cheaper and more exact images. Chromolithography used a 26-step process, resulting in luxurious color prints. This process was soon replaced with faster techniques. With these advances, trade cards became the rage. These portable and prolific advertisements were given freely to announce new drugs, promote their use, and proclaim their efficacy. It is notable that several of these patent medicines seemed to work because they were laced with alcohol, opium, morphine, and the like. These would certainly divert one's attention from pain and suffering, at least for a while. Hood's Sarsaparilla is a good example of a product touted as a cure-all for rheumatism and heart disease, and as a preparation for purifying the blood. It was almost 20% alcohol.

In the late 1800s, print advertising really took off. For example, Beecham's Pills, a mild laxative, spent the equivalent of over £50 million on advertising in one year.[21] Hood's Sarsaparilla, with a huge manufacturing plant in Lowell, Massachusetts, offered a whole line of activity premiums, like wooden puzzles and calendars geared to children, as it became apparent that they could be influenced by the graphics in the ads. In 1897, for ten cents and one coupon, the child would receive a set of Hood's Paper Dolls.

Pharmaceuticals and patent medicines began to be advertised in greater numbers during the Civil War. It was then that manufacturers of patent medicines directed advertising to a national market in newspapers, magazines, pamphlets, and many other forms of printed material. Soldiers with dysentery and diarrhea needed help. Companies producing medicines in large quantities advertised directly to consumers nationally and were the first to use psychological techniques to lure prospective customers. For example, patriotic and military imagery were used on the packaging. In the years following the Civil War, even the most ardent medical reformers often admitted that "the 'quack,' the 'shyster,' and the 'sheep in wolf's clothing'" would always exist.[22] We know that they still do. Today, the United States and New Zealand are the only two countries in the world where direct-to-consumer advertising of prescription drugs is legal.[23]

FOOD

"Our grandparents and great-grandparents and all the parents before, throughout history, expected that children would die."[24] This is the opening sentence of pediatrician and *New York Times* journalist Perri Klass in her popular book, *A Good Time to Be Born*, giving the history of infant mortality. In it, she goes on to say, matter-of-factly, as the above comment explains, "Children used to die, regularly and unsurprisingly." Infant mortality (i.e., death before the end of the first year of life) and child mortality (i.e., death before the end of the fifth year) knew no boundaries between rich and poor, even into the twentieth century. Infant and childhood death were featured prominently in the great literature of the eighteenth and nineteenth centuries. The dehydration of diarrhea and often the contaminated water used to combat it were the principal culprits.

It was only in the late nineteenth century and early twentieth that infant mortality was even calculated.[25] In nineteenth-century Britain, infant mortality remained at 149 deaths per 1000 births.[26] At the same time, child mortality was over 40% in Southern and Eastern Europe, 20% in Norway and Sweden, about 25% in England, and 30% in France.[27]

Dr. Klass explains that at the end of the nineteenth century infant death was beginning to be attributed to society's "health and hygiene" and was not "a biological inevitability."[28] All of these facts and beliefs enables one to appreciate the proliferation of food advertising that presented nutrition as a contributor to children's health. Health promotion in advertising appeared even earlier, at the end of the eighteenth century and in concert with the Industrial Revolution, and featured the health benefits of new inventions, like safe stoves, less caustic soaps, and even metal polish.[29] Of course, cure-alls and pharmaceuticals also played upon the reality of children's mortality. (See Pharmaceuticals above.)

Many of the early food advertisements were directed at nourishing children. The ad for Kellogg's Krumbles in the exhibition (cat. 14) states: "You can't possibly give your children a healthier or tastier food . . ." Kellogg's was among the first companies to claim they provided whole grains at a reasonable cost and offered a money back guarantee. Whether or not these products were targeting picky eaters, many proclaimed their ability to get children to eat, like the Snap! Crackle! and Pop! Rice Krispies' split page booklet from 1933 (cat. 16) declaring the parent will "have a real treat in watching the happy youngster listen and then *eat.*"

Henri Nestlé (1814–90), a Swiss pharmacist, "recognized a need in society . . . to develop a suitable product to combat the raging infant mortality prevalent at the time."[29] He had been asked to come up with a product to help a friend's child who could not digest cow's milk.[30] Nestlé called his product Milk Food, a powdered baby food. To this day, the name Nestlé is a world-recognized brand.

Other early chocolate products promised nourishment, like the Van Houten's Cocoa ad that promises "Strength, Purity and Solubility." The claims in these pop-up ads were supported by three prominent medical journals, including *The Lancet.* With a nod to the adult buyers of these products, in the Chocolat Cie. D'Orient metamorphic ads in the exhibition (cat. 32), we see a man drinking

beer and another using snuff.. But the advertising slogan on each states, "créations pour déjeuners des enfants" or "creations for children's lunches."

The chocolate company Guérin-Boutron outdid themselves with the four-slat transformation cards, each presenting a fable by Jean de la Fontaine. The fables in the 45 cards represented in my collection succinctly tell the tale with a pull of the tab that changes the image. There is another set of similar cards giving the biography of famous painters like Peter Paul Reubens (cat. 33), Frans Hals, and Léon Bonnat. The reverse side of the cards commends the chocolate and highlights its solubility without boiling. There are a great many lithographed cards by Leopold Verger of Paris in my collection. He also created transformational advertising cards for the Au Bon Marché department store.

Many of the cards, like the Guérin-Boutron ads, seek to educate the public while promoting their products. The Phosphatine Falières company printed a large number of cards with information about the provinces or regions of France and France's colonies (cat. 20). This cereal, rich in calcium and directed at treating anemia, which was rampant among nineteenth-century children, was also developed by a pharmacist, Émile Falières. Considered so nutritious, especially for bone-building, it was added to the diet of starving Belgian children during and after World War I.[31] An added enticement was the DIY aspect of the card. Follow the directions, in French, on the reverse side to make the ad move. The movable on the front needed to be attached to the "tirette" controller (pull-tab) on the back. Most of my Phosphatine cards had already been assembled and sewn.

Baron Justus von Liebig, in 1867, brought to market a soluble substitute for mother's milk (cat. 19). He never challenged the benefit of breast milk, but touted his product, Liebig's Soluble Food for Babies, as being equal to it and better than a wet-nurse's milk.[32] This product, derived from South American beef, was later prepared as a powder. The rampage of the Industrial Revolution had consumers open to new products. The new middle class could afford these luxuries and spent more time out of the home, thus requiring more convenience foods.

Like many ephemera in my collection, they exist because someone valued its content or appeal enough to save it, sometimes for almost 200 years! Aware that their attractive cards remind the owner of their products, many of them were included in the packaging itself. Liebig issued scrapbooks to help ensure that they were being saved.

Another company providing a scrapbook for their ads was the cheese, *La Vache qui Rit*, or *The Laughing Cow"* (cat. 39). The artist, animator, and illustrator who created the large cast of animal characters presented in the ads was the Frenchman Benjamin Rabier (1864–1939). Many of Rabier's characters came to life with movable paper, contributing to their collectability.

Although infant and child mortality became less of a problem into the twentieth century, children were still the target of many advertisements. Radio and television ads would make them more aware of food products, among others, and promotional items and premiums were attached, or even included in products, to entice the children to "beg" their parents for them. Remember quickly finishing your Cracker Jacks to get to the prize at the bottom? (cat. 67).

An entire industry devoted to creating premiums and promotional items, led by Sam Gold, contributed to this revolutionary idea of giveaways. Gold is reported as saying, "the world's greatest super salesman was a child, able to sell to mom and dad when no one else could."[33] Sam was later joined by his son, Gordon, and their company became the largest producer of premiums that supported a variety of products, from cereals to large appliances. Gordon created premiums that any company could use by putting their name and/or logo on it (cat. 23). According to art director Steven Heller and illustrator Steven Guarnaccia, "Young children learn to read logos before letters and words."[34] Food product advertising is big business, and one only has to watch a bit of television or leaf through a magazine to see that that's so.

INDUSTRIAL DESIGN

The Industrial Revolution was in full swing in the nineteenth century, called by some "the Golden Age of Innovation."[35] New inventions generated major cultural shifts. Some of the great inventors of the era were Thomas Alva Edison, Nikola Tesla, Alexander Graham Bell, and Isaac Singer (cat. 45), to name a few. Millions of patents were applied for and won, mostly by individual inventors in their shops. These inventors tended to be, by and large, men who were white and unmarried.[36] Patents were also extended to unique paper mechanisms, especially in England and the United States.

Workers became more educated and versatile in their skills. They moved to urban areas where manufacturing was centered. Through the ability to harness the forces of nature for economic improvement, "the lower middle class in Western and Asian industrialized societies today have a higher living standard than the pope and the emperors of a few centuries back. . . ."[37]

AUTOMOTIVE

One might say "big ticket items require big advertising." The first auto advertisement was in the *Scientific American* newspaper in 1898, offered by the Winton Motor Carriage Company of Cleveland, Ohio. The car cost $1000, and the ad concentrated on convincing the consumer to switch from a horse to an automobile. Like any good ad, the features and benefits of the product were highlighted: cheaper to run (1/2 cent per mile), speeds of 20 mph, and without an odor. With the headline, "Dispense with a Horse," the ad proved to be effective (cat. 58).[38] As people accepted the auto as a mode of transportation, competition picked up and ads became less direct and more sophisticated and subtle. The advent of television allowed manufacturers to demonstrate an automobile's many features and how it performed.

Not to be overlooked are the automotive advances made on farm equipment with several time- and labor-saving machines. Farmers also made the transition from horse-drawn equipment to those powered by gas. These mechanical farm implements were also advertised in targeted media (cat. 44).

Despite this early start in car ads, my collection doesn't pick up steam until the 1920s, when a cigarette lighter manufacturer created a movable card with a woman in an unnamed car lighting her cigarette (cat. 59). In these early beginnings of car advertising, the car's function was promoted over style. That changed as consumers, mostly the sophisticated and social elite, started to pay attention to the car's design features. Ads for motor oil proliferated as well. Meyrel Motor Oil has a woman holding a grease gun (cat. 60). In the 1950s, the Esso Company in France created a character, Monsieur Souffran, who appeared in booklets praising the unique qualities of Esso Motor Oil (cat. 68). There are several in my collection, all movable of course. A garage or gas station could put their name or logo on the booklet.

The first woman to work in the automotive field as a designer was Helene Rother [Ackernecht] [1908–99], originally of Leipzig, Germany. Using her skills in jewelry, fashion design, and book illustration, she was able to secure a position as an interior designer of Nash cars. So successful were her interiors for Nash Ramblers, "appealing to the feminine eye," her name was used in its advertisements. This focus on the importance of style and quality in a car's interior turned out to be influential in all of automotive design and contributed to the success of sales. Rother was posthumously inducted into the 2020/2021 class of the Automotive Hall of Fame.[39,40]

Today the "top five automakers spend about 25 million U.S. dollars on ads in a single calendar year, led by Volkswagen." But digital advertising was expected to reach 5.3 billion dollars in 2021.[41] "Successful publicity" is that kind of publicity which produces results which justify expenditures."[42] This quote was from P. Lorillard Company, manufacturers of tobacco but which seems universally applicable to general advertising.

HOUSEHOLD ITEMS

The Industrial Revolution, especially in America and Europe, brought a rise of the middle class with newly found leisure time and discretionary money to spend. Furniture, including at the workplace, could also make daily life easier as well. Ads for items like sewing machines, desks, windows, and even in-home elevators are in the exhibition (cat. 48).

THE BUSINESS OF BUSINESS

The first business cards were termed visiting or calling cards, announcing the arrival of a visitor, whether for business or pleasure. The Chinese in a fifteenth century tradition printed cards for these purposes. Using the cards reflected the presenter's importance and elaborate rules of etiquette surrounded their use. As with other paper advertisements, the progression of printing followed the advancements of those times, from woodblocks to lithography to chromolithography to digital printing, among other techniques. Today, I print my own color business cards.

In the seventeenth century, before businesses had formal street addresses, trade cards would show maps on the reverse side to provide the shop's location.[43] It would be important for the cards to be eye-catching and informative so that the recipient would be motivated to keep them. The business cards in this exhibition uniquely have movable paper elements, becoming collectibles in their own right (cat. 96). The interactivity of each card helps ensure the recipient will "play" with it and retain the paper engineer or company's name. I'm not above begging for the pop-up business cards that paper engineers create in limited numbers and give out surreptitiously.

There are many other ways businesses present themselves in an effort to induce the recipient to retain the information whether in an advertisement, giveaway, or annual report. One of the most elaborate annual reports in this exhibition is the one from Intervisual Books, the largest pop-up book packager during its time of operation, who placed one of its yearly reports at the back of its pop-up book, *Haunted House* (1979) (cat. 84).

At the pinnacle of design complexity is the 2010 annual report for the Acuity Insurance Company of Sheboygan, Wisconsin (cat. 91). The entire report is a pop-up book, with each nursery rhyme spread describing an attribute of the company or its products. It was distributed exclusively to their 19,000 insurance agents. Several agents objected to this highly expensive method of self-promotion.

Enticement and inducement are keys to having a company's name and/or logo retained in a consumer's mind. Other gimmicks used are annual reports in the shape of the product, like the Eskimo Pie ice cream pop (cat. 86), and BLADs (book layout and design) for pop-up books that offer a single pop-up or movable spread from the book in marketing to a publisher or bookseller (cat. 55). Structural Graphics in Essex, Connecticut is an agency devoted to creating these unique movable paper advertisements.

SIN PRODUCTS

TOBACCO

A so-called sin tax is levied on products that may cause harm if abused or overused. The taxes simultaneously raise revenues and also seek to lower the consumption of these products, like tobacco and alcohol. I have always maintained that the advertisements with the most bells and whistles, i.e., with the most complex mechanicals, and printed in the greatest numbers are produced by those companies with the deepest pockets, which is the case for automobiles, tobacco, alcohol, and pharmaceuticals.

Tobacco companies used many methods to incentivize people to smoke. To make smoking seem cool, images portrayed happy vacationing families, people living the high life with fancy cars, or just plain sex appeal, like scantily clad women. My earliest tobacco ad is for Players Navy Mixture, a tobacco product that could be smoked in a cigarette or pipe. What were they thinking circa 1888 when

they have a child climbing a tree only to find under the flap a pack of Player's Navy Cut cigarettes? (cat. 124).

The pop-up magazine insert for Quest cigarettes purports to lessen the intake of nicotine but states they are not intended to help stop smoking (cat. 129). Yes, they do have less nicotine but still contain the carcinogens like other cigarettes. The use of these "decreased risk cigarettes have not significantly decreased the disease risk."[44] Free cigarettes were often given out in special packaging or offered with coupons, like the one for Camels (cat. 128).

Tobacco cards, inserted to stiffen the packages, were a popular collectible premium. The 1939 Herbert Tareyton cards had their own illustrated envelopes. Pull out the miniature card and a landmark British building pops up. There were 24 in the set (cat. 125). Tareyton produced several flat card series as well, like those with British royalty. I imagine children asking their parents to smoke more to get the series. Sin products, indeed!

<div align="center">ALCOHOLIC BEVERAGES</div>

For millennia, drinking has been mostly associated with having fun, increasing one's sprightliness, and contributing to a festive atmosphere. Those companies who produce hard liquor and beer face fierce competition but retain the wherewithal to vie for the imbiber. This ability probably accounts for the intricate and, therefore, costly movable advertisements and premiums associated with alcoholic beverages. According to Fowlers Publicity Encyclopedia, "The province of the advertising novelty is to present to the customer . . . something of a tangible or more or less permanent value."[45]

My favorite of the alcohol-related ephemera is one produced by the governor for Wisconsin's Traffic Safety Coordinating Committee, the Drink/Drive Calculator. A double-sided volvelle, it tries to alert the imbibing driver of the risk of drinking while driving, namely, how much alcohol will cause impairment in what amount of time, estimating one's blood alcohol level (cat. 118).

In the 1980s, Absolut vodka launched one of the most memorable ad campaigns, especially for an alcoholic beverage. Some magazine inserts offered gloves or a jigsaw puzzle, and on Father's Day, a necktie. The Christmas magazine insert included an embedded microchip that played a Christmas carol. By 2000, Absolut's advertising budget was $33 million, according to *Business Insider*. Such was the enthusiasm for the ads, and the bottles themselves, that three Facebook groups were formed. One, called My Absolut Vodka Collection, has over 4000 followers. Sales of the vodka went from 10,000 cases in 1980 to 4.5 million in 2000.[46] It appears these collectible promotional inserts contributed to the company's popularity (cat. 123).

In addition, liquor and tobacco purveyors financially back and endorse big events such as Budweiser's Made in America festival in Philadelphia or, in the case of tobacco, the Virginia Slims tennis tournaments.[47] Their logos and swag are ubiquitous.

<div align="center">FASHION AND BEAUTY</div>

It was around the time of the Civil War that consumerism began to take off. Manufacturing had escalated during the Industrial Revolution. A confluence of events and inventions added to this phenomenon, namely, the introduction of the sewing machine, improved by Elias Howe in 1846, the transcontinental railroad, which brought goods to the pioneering West, and the rise of the middle class with greater disposable income. Consumers were no longer confined to what was sold locally or to hand sew their own garments. With the introduction of the Sears, Roebuck catalog in the 1890s, clothing could be bought ready-made, causing designers and manufacturers to compete for orders.

There had been fashion magazines, like the French *Le Mercure Galant* in the seventeenth century and named designers, like Rose Bertin, Marie Antoinette's stylist, as well.[48] Pandoras, or fashion dolls, wore designer clothing for mostly women to choose and have made in their size.[49] Visitors to Versailles and King Louis XIV could only show their wealth by the clothes they wore. Fashion plates,

literally color drawings, were sold in the form of subscriptions to the wealthy. In addition to the dolls, fashion design was printed on paper and sold by subscription in sets, called *cahiers*.[50]

Extravagant styles filtered down to members of the middle class, who later in the nineteenth century sought trendy styles in fashion magazines that also printed fiction, gossip, and patterns for creating clothes. In addition to fashion articles, also featured were those on crafts, recipes, fashion accessories, and sundries. With the mid-century creation by Madame Demorest of sized paper clothing patterns for home dressmaking, another whole industry was born. Pioneer women who had the means and interest could dress in finery like those on the East Coast or Europe.

The first mail-order catalog by Montgomery Ward in 1872, followed by Sears, Roebuck and Co., allowed people across the country to dress *en vogue*. Needless to say, store-bought clothes saved time for those who had been slaving at a home sewing machine or hand-sewing outfits for their families. While mail rates for catalogs fluctuated, Congress continued to subsidize the US Postal Service. Lowered rates facilitated the shipping of the catalogs and made purchases more affordable. Even when rates climbed, mail order buying continued.[51]

At the same time, the Parisian Au Bon Marché department store, discussed above, was breaking all the established customs for running a retail establishment. Among its many innovations were set prices—previously, haggling was the way prices were established—and displaying merchandise for patrons to handle instead of on shelves behind the counters.

American department stores used similar techniques and shopping became an acceptable hobby, mostly for women. Part of the Flatiron district of New York City, between 15th and 24th Streets from Sixth Avenue to Park Avenue South became known as the Ladies' Mile, and was lined with notable stores like Macy's, Tiffany & Co., and Lord & Taylor. Luring women to the stores or tempting them with fashion made advertising a necessity. The artwork for fashion posters could be of high quality drawn by such artists as Toulouse-Lautrec and Alphonse Mucha, among others. Class distinctions, especially in England, were apparent not only in the artwork, paper quality and language of the advertisement but especially in the quality of the goods, like the fabric.[52]

Competition for women's attention brought about branding and recognition of a single manufacturer, especially by its logo. This consumerism was enhanced by middle-class women becoming keepers of the purse strings. Magazines, targeted at women, became a major conduit for advertising to the homemaker.[53] Like today, designers competed to dress the most recognizable women in society. The fashion and beauty industries also included jewelry, make-up and undergarments, and these are all represented in the exhibition (see, e.g., cat. 154).

HOLIDAYS

Holiday excitement, when people are hyper-focused on the event, is an opportunity for companies to advertise their wares. This is especially true of Christmas, Chanukah and others, with their traditions of exchanging gifts. The rituals and customs associated with the holidays allow companies whose products are involved in them, like gifts, paper goods, decorations, and traditional foods, to get their message, name, or icon out in front of the consumer. Barricini chocolates for Passover and F. A. O. Schwarz toys for Christmas are two examples in the exhibition (cat. 159, 162). One very helpful piece of ephemera, a volvelle, enables the user to select a gift for everyone in the family when they appear in a die-cut hole with gift suggestions displayed in another. On the reverse, one can locate the gift in the store, floor by floor, in the die-cut holes. This "Magic Christmas Gift Selector" is a prototype for a promotional item with space for the store's logo and related imagery (cat. 158). I don't know if it was ever produced, but what a great helpful idea! Printers selling these promotional ephemera often left space for a company's contact information and a brief pitch.

It was important to make a promotional item useful and practical so that people would hang on

to them and absorb and mentally retain the name of the company. At Christmas, advent calendars with logos and names are a common example. The Haysville Service Station (Kansas), "Where tires are a business—not a sideline," gave out a pop-up card with a mirror printed with their name. A useful item like a mirror would tend to be kept indefinitely and remind the consumer where to get their gas and tires (cat. 157). Personalized holiday greeting cards, like the one sent by Liberace (cat. 161), can be seen as a form of self-promotion.

TRAVEL

Who among us hasn't stashed away a souvenir of an event or trip? When we come upon it later, we immediately are brought back to that time or place. We tend to hold onto these things to revive those memories. Companies and organizations count on the keepsake to maintain your awareness of their product, making them as useful and appealing as possible. Airlines, events, or tourist sites all want you to return. The more practical the object, the better chance you will keep it.

Those objects that advertise a location or event get your attention when a movable is added. A thick envelope in my mail raises my hopes that a movable card may be inside. I open these quite carefully. This was true of the Cartier invite for a Fifth Avenue store event (cat. 146).

In another example, according to the envelope's return address, a Splash Mountain invitation came from Disney's Special Events department (cat. 173). Disney had partnered with Delta Airlines for this pop-up ad for the October 1-3 opening of their Florida Splash Mountain ride in 1992. Delta calls itself "The official airline of Disneyland and Disney World." Two bangs for the buck. Matchbook covers, with pop-ups inside, are also a great way to keep one's name visible, at least until the matches run out (cat. 172).

Postcards, heavily represented in my ephemera collection, are easily bought at major tourist attractions. Beginning in 1869, Emanuel Alexander Herrmann (1839–1902), a Viennese economist, proposed using an envelope-sized card for mailing with reduced verbiage (twenty words including address) and requiring lower postage than a letter. The idea became a postal sensation worldwide and the word restriction was subsequently dropped. Initially, the postcard's address and message occupied opposite sides of the card. That changed in Europe in 1902 when the divided back was instituted; the front could now be used for artwork, graphics, novelties, like movables, and photos. In 1907, the US Postal Service approved the same design. At the 1898 World's Columbian Exposition, souvenir postcards of the fair's buildings were distributed, the first time souvenir postcards were given out.[54] Landmark buildings such as Moscow's Luzhniki Stadium, and New York's Empire State Building, Flatiron Building, and Statue of Liberty (cat. 43, 170) are prominent in this exhibition.

ARTS, ENTERTAINMENT AND POLITICS

In the spirit of "if you build it, they will come," no entertainer wants to play to an empty house. Therefore, one must promote and advertise the event in order to attract an audience. Whether in a playbill, program, magazine, or radio announcement, the message that the show is going on must be broadcast loud and clear. Most of these announcements are ephemeral in nature, serving to draw attendees to the event and no further. In some cases, like the Little Orphan Annie radio spots, children could send for character puppets that can be continually played with, hence keeping the show in the audience's mind (cat. 184). Or, in the case of collectible cards, like limited edition Star Wars cards, the promotional items remain keepsakes (cat. 189).

MUSIC

As if the music itself is not enough of a draw to have the listener buy the record or CD, record sleeves or CD jewel cases are many times embellished with dimensional paper. Digital downloads, of course, don't (or can't) use these enticements. One example is the jewel case for the Ditty Bops's

CD *Summer Rain*. It has the distinction of being nominated for a Grammy Award for Packaging in 2008. It is a standout with multiple mechanicals giving relevant information about the group and this recording (cat. 197).

SPORTS

Food companies, like Stouffer's and Kraft General Foods, used sports figures to promote their brands. Printing cards of popular sports personalities, like baseball pitcher Roger Clemens (cat. 199) and catcher Yogi Berra (cat. 200) ensured that the food brand's logos would be saved and prized. Usually published in sets, sports cards have become a hot commodity especially if one obtains a rookie card for a popular player. But the most valuable card in sports history, published and placed in a cigarette package by American Tobacco, is the 1909 Honus Wagner card. He played baseball for the Pirates. In 2021, the card sold for $3.2 million. Many a mother has been maligned for discarding their sons' baseball card collection.

MUSEUMS AND GALLERIES

The energy and money poured into exhibitions demand that people come to see them. That's especially true of galleries where art is sold. Museum and gallery invitations are treasures in my collection, and again, testimony to their keepsake value. Some, like the peepshow card from the American Museum of Natural History in New York, are quite elaborate (cat. 177). Perhaps it was a gift for donors. Represented in the collection are invitations to gallery openings for Salvador Dali (cat. 179), Tauba Auerbach, and Louise Nevelson. I especially like the volvelle created by the United States Air Force Library Service showing the standard times in cities around the world. The tag line on the back is "Wherever you are[,] Use your Base Library" (cat. 178). Indeed!

POLITICS

When it comes to politics and elections, promoters want the electorate to get the party's and candidate's message clearly and succinctly and retain it at least through Election Day. Produce an attention grabber, like pop-ups and movables that provide all the information, and hopefully you've accomplished your goal (cat. 204)

FINIS

From the beginning of time, maybe starting with drumbeats, mankind has wanted to get a message across to others. And like drumbeats, these messages have been mostly ephemeral, having a brief life. Even ancient texts would have been lost to us if they had not been valued and secured and were not now available for study. We can only know and examine the past because scholars, students, scrapbookers, collectors, and just plain folk have preserved these communications. My collection, and those ephemera collections held by other collectors and institutions, owe a great debt to those who valued and maintained them.

The benefit of these assemblages is that researchers and scholars can study them and better understand how past communities, organizations, and individuals lived and interacted, and what they prized. The basic function of advertising is communication made up of the message and the vehicle. Making these ephemeral objects as beautiful and interactive as possible adds to their likelihood of survival.

The goal of this exhibition and catalog is to share these messages, highlighting the use of mechanical and dimensional paper and unique and varied presentations. These premiums and promotional items are but the tip of the collection. I find them exciting in their creativity, clever in their messages, and staggering in their survival. It pains me to think how this digital age will rob the future. Without these corporeal examples, what material will there be to maintain and study?

NOTES

1. Breskin, "Premiums in Plastic," 158.
2. Nagle, "Trading Stamps," 7.
3. Breskin, "Premiums in Plastic," 158.
4. Yates interview on *NOVA: Ancient Worlds.*
5. Norman, "Caxton Prints the First Book Advertisement."
6. Blake, *William Caxton*, 206.
7. Tungate, "Pioneers of Persuasion," 11.
8. *AdAge Encyclopedia*, "History: Pre-19th Century."
9. Tungate 11.
10. Crouse, "Business Revolution: The Ad Agency."
11. Smith, *Advertise: How? When? Where?*, 36.
12. Harvard Business School, *The Art of American Advertising.*
13. Maguire, "From 3-D to Pop-ups."
14. Kirsch, *Chromos*, 18.
15. Ibid., 29.
16. Heller and Guarnaccia, *Designing for Children*, 150.
17. Kirsch, *Chromos*, 35.
18. Greene, *Advertising and Popular Culture*, 65.
19. Miller, *The Bon Marché*. 14.
20. Sorisi and Bruno, *Catalogue au Bon Marché,* iv.
21. British Library, "Beecham's Pills."
22. Boyle, "Quackery and the Civil War."
23. Lee, "How Is Consumer Drug Advertising Regulated?"
24. Klass, "Introduction," 1.
25. Ibid., 18.
26. Dyhouse, "Working-Class Mothers," 1.
27. Pozzi and Ramiro Fariñas, "Infant and Child Mortality," 55.
28. Klass, "Introduction," 18.
29. Lambert, "Mirror of Society?," 182.
30. Nestle.com, *Nestlé: Good Food Good Life.*
31. The Hooded Hooligan, "The Cookie Quest Chronicles."
32. Olver, *FAQs: Baby Food.*
33. *Scoop Newsletter*, "The Premium History of Sam and Gordon Gold."
34. Heller, *Designing for Children*, 150.
35. Akcigit et al, "When America Was Most Innovative, and Why."
36. Ibid.
37. Swanson, "Industrial Revolution."
38. Altered Steel, "History of Car Advertising."
39. Altered Steel, "Helene Rother".
40. Wikipedia, "Nash Rambler".
41. Altered Steel, "History of Car Advertising".
42. Fowler, "P. Lorillard," 55–56.
43. Casey, "History of Business Cards."
44. Shopland, "Risks Associated with Smoking."
45. Fowler, "Novelties," 488-91.
46. Baer et al, "17 Iconic Ad Campaigns."
47. O'Loughlin, "Alcohol Brands."
48. Walker, "Selling Style 1."
49. "Pandora."
50. Walker, "Selling Style 1."
51. United States Postal Service, "Postage Rates for Periodicals."
52. Lambert et al, *Art of the Advertising,* 69–98.
53. Ibid., 135.
54. McBride, "Postcard History."

NOTE: All items in the catalog that follows are of printed cardstock unless otherwise stated.

CATALOG OF THE EXHIBITION

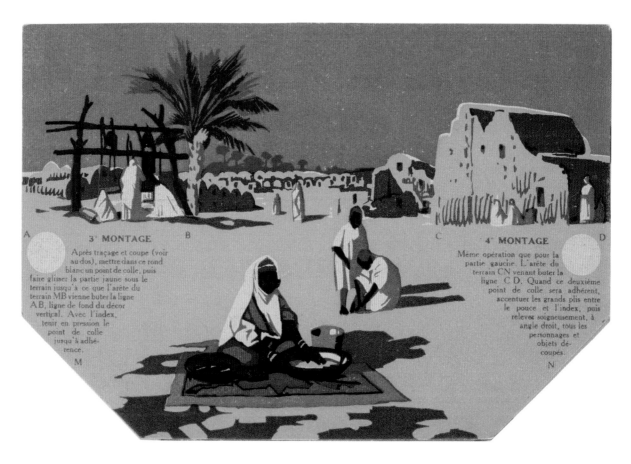

3ᵉ MONTAGE

Après traçage et coupe (voir au dos), mettre dans ce rond blanc un point de colle, puis faire glisser la partie jaune sous le terrain jusqu'à ce que l'arête du terrain MB vienne buter la ligne AB, ligne de fond du décor vertical. Avec l'index, tenir en pression le point de colle jusqu'à adhérence.

4ᵉ MONTAGE

Même opération que pour la partie gauche. L'arête du terrain CN venant buter la ligne CD. Quand ce deuxième point de colle sera adhérent, accentuer les grands plis entre le pouce et l'index, puis relever soigneusement, à angle droit, tous les personnages et objets découpés.

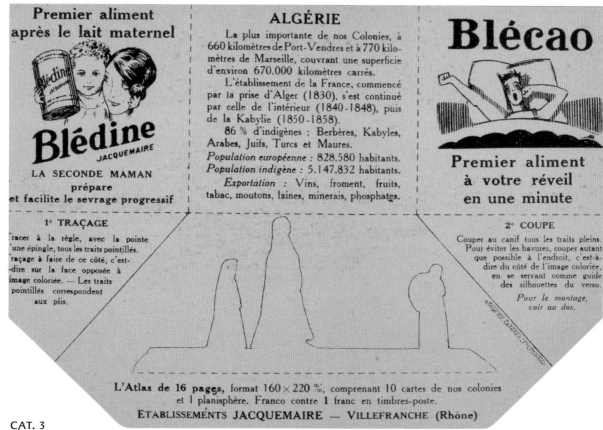

Premier aliment après le lait maternel

Blédine
JACQUEMAIRE

LA SECONDE MAMAN
prépare
et facilite le sevrage progressif

ALGÉRIE

La plus importante de nos Colonies, à 660 kilomètres de Port-Vendres et à 770 kilomètres de Marseille, couvrant une superficie d'environ 670.000 kilomètres carrés.

L'établissement de la France, commencé par la prise d'Alger (1830), s'est continué par celle de l'intérieur (1840-1848), puis de la Kabylie (1850-1858).

86 % d'indigènes : Berbères, Kabyles, Arabes, Juifs, Turcs et Maures.

Population européenne : 828.580 habitants.
Population indigène : 5.147.832 habitants.

Exportation : Vins, froment, fruits, tabac, moutons, laines, minerais, phosphates.

Blécao

Premier aliment
à votre réveil
en une minute

1° TRAÇAGE

Tracer à la règle, avec la pointe d'une épingle, tous les traits pointillés. Traçage à faire de ce côté, c'est-à-dire sur la face opposée à l'image coloriée. — Les traits pointillés correspondent aux plis.

2° COUPE

Couper au canif tous les traits pleins. Pour éviter les bavures, couper autant que possible à l'endroit, c'est-à-dire du côté de l'image coloriée, en se servant comme guide des silhouettes du verso.

Pour le montage, voir au dos.

L'Atlas de 16 pages, format 160 × 220 ᵐ/ᵐ, comprenant 10 cartes de nos colonies et 1 planisphère. Franco contre 1 franc en timbres-poste.
ÉTABLISSEMENTS JACQUEMAIRE — VILLEFRANCHE (Rhône)

CAT. 3

Pharmaceuticals and Health Care

1. *Medicinal Dynameter and Scale of Equivalents*, from the Second American edition of John Ayrton Paris's *Pharmacologia*, New York: F. & R. Lockwood, 1824. 8½ x 5½".

Usually placed on the endpaper of textbooks, this cardboard volvelle will aid the physician in finding equivalent doses of active ingredients from one medication to another. The physician John Ayrton Paris (1785–1856) devised this volvelle to help practitioners understand the ingredients in the medicines they were prescribing and in what doses they may be safely combined with others.

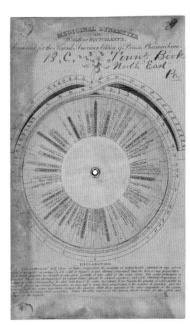

CAT. 1

2. *Maltine Obstetrical Calendar.* G. W. Lawrence, M.D., 1892. 4½" dia.

Maltine Plain, manufactured by Reed & Carnrick in New York (and later in New Jersey) is a food supplement made for infants, children, and pregnant women to help with nutrition and digestion. This volvelle could help calculate a pregnant woman's due date. The product contained high amounts of alcohol and several other ingredients, described on the back, like cocaine and strychnine. The company's ads included a number of doctor testimonials and appeared in medical journals during the 1880s. Several products were sold in cobalt blue and amber bottles that are quite collectible today.

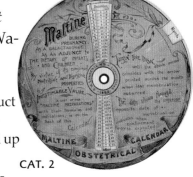

CAT. 2

3. Blédine and Blécao Jacquemaire, Villefranche, France. *Premier aliment après le lait maternel* [*First food after breast milk*], [ca. 1900]. 4⅛ x 6¼". O. Waton, printer, St. Etienne, France.

Blédine food additive can be considered a pharmaceutical product due to its health claims: *Ameliore l'allaitement au biberon* [*Improves bottle feeding*]. Blécao is a similar product with added vitamins for older children and adults. This is a Blédine DIY chromolithographed card from a set of ten. Cut around the foreground figures to make them stand up in the tableau. Each card contains a write-up on one of the French colonies, Algeria in this example, with its history on the reverse. French colonialism was at its most expansive at the turn of the century. The company also offers a scrapbook to store the cards.

4. Pastilles Valda, Paris, France. *M'aime-T-On?* [*Do you love me?*], [ca. 1900]. 4" dia.

Turn the wheel with the extended tab to choose the cause of throat irritation. How well these throat lozenges will work appears in the die-cut hole. The reverse shows a beautiful reproduction of the container. Pastilles Valda are still sold today.

5. *Elixir de Kempenaar Liqueur Hygiènique*, Belgium, [ca. 1905]. 6½ x 2⅝".

Pull-out cards with unrelated humorous chromolithographed illustrations—more for children than adults—were used by many companies at the turn of the century. The promotional text on the card's reverse includes a black-and-white country scene. The term "hygiene" (or "hygienic") was commonly used to refer to good health practices and leads me to believe they were trying to convey a medicinal benefit to their alcohol product. There is little text that speaks to the product itself. Jacques Neefs, a well-known Belgium wine and spirits merchant, often used this large series of Elixir cards to promote his business.

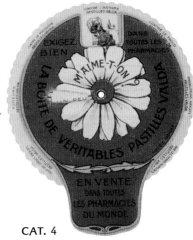

CAT. 4

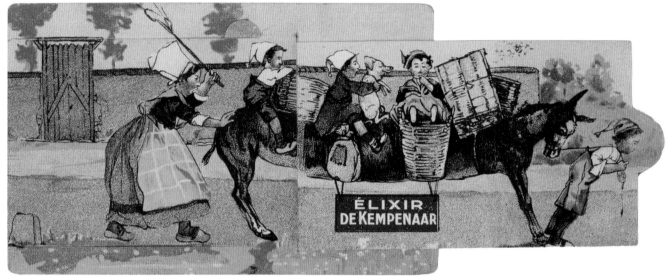

6. La Blédine Jacquemaire, Villefranche, France. *meunier, tu dors* [*miller, you sleep*], [ca. 1912]. 4½ x 3¼". O. Waton, printer, St. Etienne, France.

This is a DIY premium, available for postage stamps equal to one franc, that required the recipient to assemble. The volvelle rotates around a knotted thread showing a sleeping boy waking when seeing the Blédine product. The reverse of the card reads: *"Blédine est une Farine spécialement préparée pour les enfants en bas âge"* [*Blédine is a flour specially prepared for young children*]. Many of these food additives, aimed at children's health, were intended to counteract the infant death rate, which was at 15% in 1900. Maternal and infant mortality was high due to poor obstetric practices, delivery methods, and milk hygiene.

7. Urodonal, *Nettoie le rein* [*Cleanse the kidney*], [ca. 1912]. 5½ x 3½". A. Ehrmann, illustrator; Leopold Verger, printer.

This product advertisement for an oral medication was printed in several languages. Besides treating urinary tract infections, it also claimed to treat rheumatism, gout, sciatica, and obesity. Verger printed numerous movable advertising pieces in this collection.

8. *Ziron will steady your nerves*, 1914. 4⅜ x 7⅝".

Sometimes called a Bang Gun, this cardboard advertising premium is geared to children but is actually an iron supplement for adults. Give the gun a sharp flick of the wrist and the triangular paper will shoot out from the barrel and give off a loud bang, like a gunshot. Quite a surprise! This type of device is used for an array of promotions; see, e.g., Quaker Oats (cat. 23).

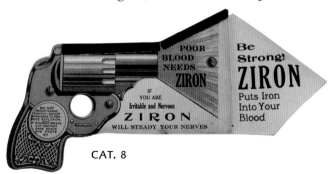

CAT. 8

CAT. 7

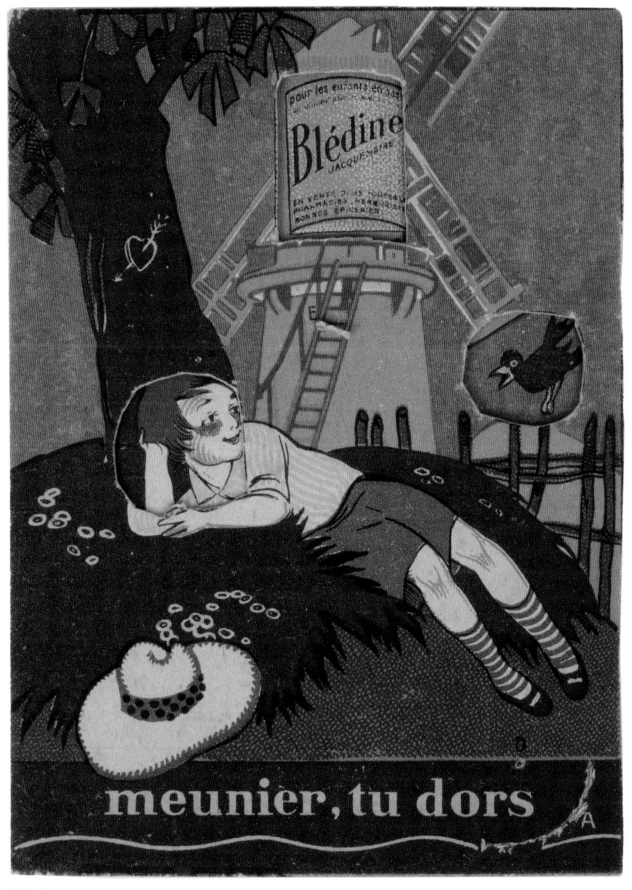

CAT. 6

9. Colgate Co., New York. *Colgate's Ribbon Dental Cream: You can play and work better when your teeth are kept clean*, 1922. 5½ x 6½".

The clear instructions on the reverse describe how to properly brush one's teeth; the action is reinforced by movement of the young girl's arm, with her hand holding a toothbrush, brushing her teeth. Another version of this movable card features a young boy in a similar setting.

10. Reed & Carnrick, Jersey City, N.J. *Differential Diagnosis in Renal Diseases*, 1928. 6½ x 4¾".

This pamphlet, "for the medical profession only," claims the drug Nephritin is effective only in large doses. To diagnose a kidney problem, use the wheel on the cover. The doctor then matches up the urinalysis findings with the pathology image to see the diagnosis in the die-cut hole. If it were only that easy.

11. Dr. Philippe Encausse. *Standard Bio-Physiologique: Sexe Masculin* [*Masculine Bio-Physiology*], [ca. 1930]. 3½ x 6".

It was said that Dr. Encausse, son of a famous occultist, claimed "sport is a means of strengthening the body, improving the race and creating health . . . especially for workers whose strength is threatened by the frenzy of the modern age." The body's ideal height, weight and respiratory functions at ages 6–21 are shown by pulling the tab on the card. The reverse shows the ideal numbers for women.

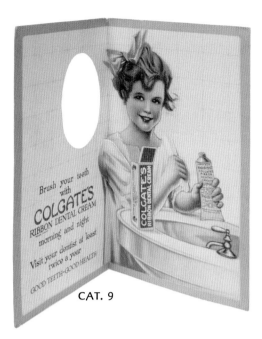

CAT. 9

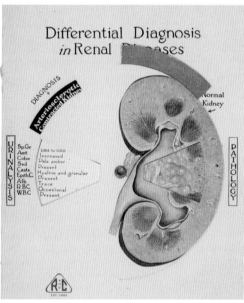

CAT. 10

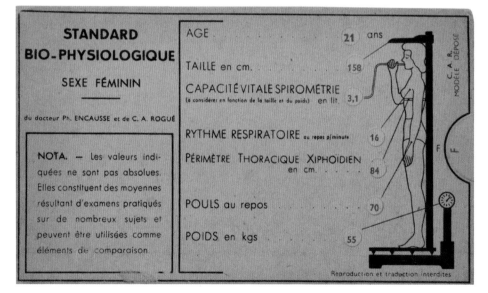

CAT. 11

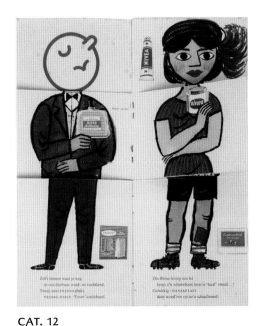

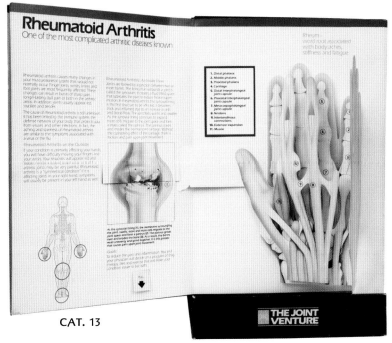

CAT. 12

CAT. 13

12. Johan Veeninga. *Nivea Toverboek* [*Nivea Magic Book*]. Hilversum, Amsterdam: Beiersdorf Manufacturing, N. V., [ca. 1960]. 8 pp., 11 x 4⅞". A. van Heusden, illustrator.

Each page is divided into thirds. Turning the cut sections will present a uniquely dressed figure, each holding a different Nivea brand. The bottom third of each page shows a different Nivea product, such as skin or hair cream, shaving soap, or cough syrup, among others. The graphics are bold and colorful.

13. Syntex Laboratories, Palo Alto, Calif. *Arthritis in Motion: A 3D Exploration of Common Arthritic Conditions*, 1985. 6 pp., 13 x 8½".

An easel supports a pamphlet intended as an educational tool for use in a physician's office. The patient is instructed as follows: "The pop-up illustrations on the following pages depict the anatomical changes that commonly occur in arthritis. They will help you to understand the essence of arthritis. . . ." The pamphlet has pop-ups, pull-tabs, and wheels for the patient to manipulate. The book holds three pads of informative tear sheets to be taken home, but they don't mention Naprosyn, the medication Syntex is promoting. Naprosyn (naproxen) is only seen printed at the back of the easel.

Food

KELLOGG'S BRAND CEREALS

14. Kellogg's *Krumbles*, Battle Creek, Mich. *What's that new food?*, 1912. 6¾ x 7⅞".

Kellogg's was so sure of their customers' satisfaction with their new Krumbles cereal that they printed a money-back guarantee on the reverse of this promotional card. The cost of the cereal was ten cents a box. I appreciate the gender-neutral "family-manager" reference to the shopper in the house.

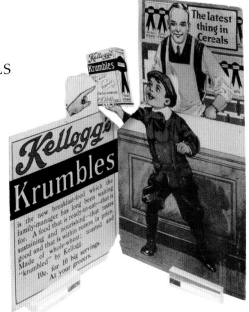

CAT. 14

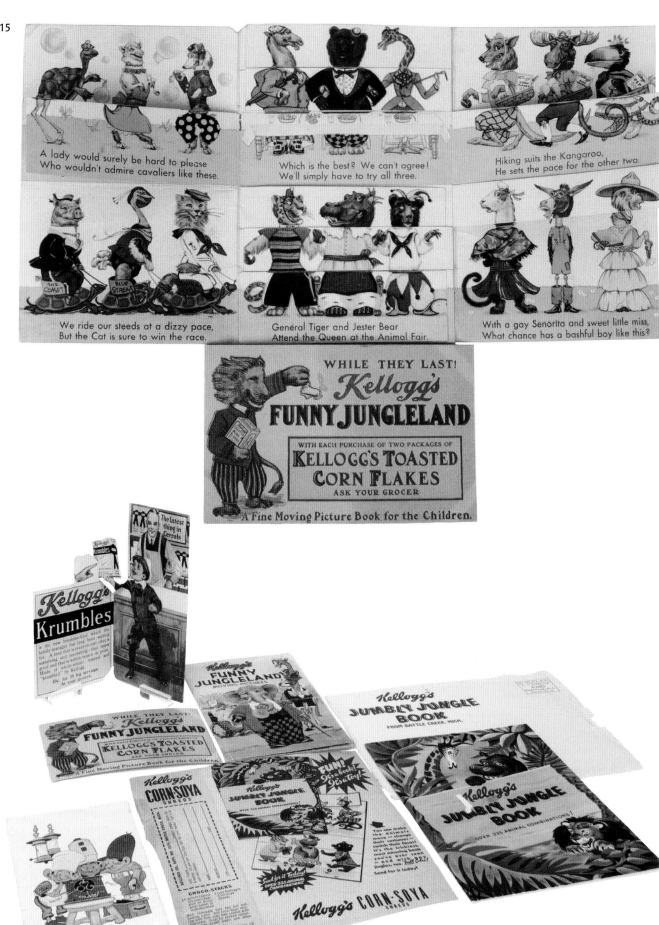

15. Kellogg's. *Funny Jungleland Moving Pictures*, 1932. 6½ x 13″.

A color triptych slice book that allows the reader to create many different fantastic animals by manipulating the illustrated flaps. Here, the story is told in verse. The Kellogg Company produced these premium booklets starting in 1909, shortly after it began using the Kellogg name. By 1932, they had printed over 25 million copies of several different iterations of *Jungleland*. Shown with a postcard offering the book when purchasing two packages of Corn Flakes at the grocer, "While they last!"

16. Kellogg's *Rice Krispies*, *Listen! Get hungry*, 1933. 5¼ x 10½″.

Another color slice book but drawn by Vernon Grant (1902–1990), the notable American illustrator. In this case, peeling aside the slats reveals another image but does not create new ones. The gnomes, Snap, Crackle and Pop, are introduced along with text promoting the cereal. In the 1950s, the dolls were available to sew for 15 cents and a box top. (I sent away for Pop.)

17. Kellogg's *Frosties*, *Les Grand Joueurs* [*Great Players*] *No. 2*, 1994. 2¾ x 2¼″.

This volvelle giveaway for the USA World Cup in 1994, number 2 in a series of 3, is a movable card that asks a question about the team's players on one side and answers it through the die-cut hole on the reverse, where it also touts Kellogg's Loops cereal as the official cereal of the 1994 World Cup. Frosties was the Frosted Flakes version of the cereal intended to appeal to adults.

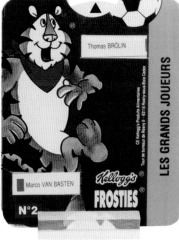

18. Kellogg's and DC Comics, *Batman & Robin*, 1997. 4 pp., 2 x 2¼″.

In the 1990s, Kellogg took on Batman and Robin as promoters of their cereals. Using the accompanying red and blue cellophane glasses will cause this miniature book to generate a 3-D effect. It was probably given away in cereal boxes. The two superheroes pop-up to defend against the villains. In Spanish.

19. Liebig Company, Paris/Uruguay/Argentina. *L'extrait de viande Liebig est un pur jus de viande de boeuf* [*Liebig meat extract is pure beef juice*], [ca. 1900]. 4 x 4".

CAT. 19

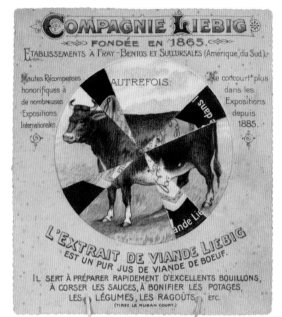

Intended for the poor and using beef from South America, Liebig would boil meat down to a paste as a substitute for real meat. The company made broad health promises despite being found to have boiled out nutritious fats and proteins. Pull the shorter string and the four "blades" circle over one another to reveal a new image. The front text boasts of the many International Exposition awards won by the product, along with its various uses. The reverse describes in depth the source of the beef in South America and its quality. This chromolithographed dissolving disc, activated by strings, is one of the more fragile movables given away by Liebig. The cost to produce it must have been at the highest end. Printing in several languages and in sets of six or twelve began in 1870 as giveaways but were later given in exchange for product coupons.

20. *Phosphatine Falières*, Paris, France, [ca. 1905]. 6⅝ x 5". Louis Chambrelent, lithographer.

Phosphatine powder, an infant food additive, fortified cereal or milk with extra calcium. Infant and child mortality was very high at the turn of the century and food additives, including chocolate, targeted children. This is one of a large series of DIY cards to be cut out and assembled by the consumer to produce a movable advertisement. The card presents Le Gascogne, a former province of France, showing a sheepherder knitting—wool from his sheep?—while his dog tends to them. Other cards in this series represent several French provinces and colonies. Sample boxes were offered.

21. Biscuiterie de Montreuil [Biscuits of Montreuil], Paris. *Zanzi*, [ca. 1920s]. 4⅛ x 3⅛". H. Bouquet, printer, Paris.

Turn the volvelle and the two boys play Zanzi, a game played with three dice. The reverse lists other products from this company.

CAT. 21

36

LA GASCOGNE

CHASSE AU GUÉPARD
AU XII^{ÈME} SI...

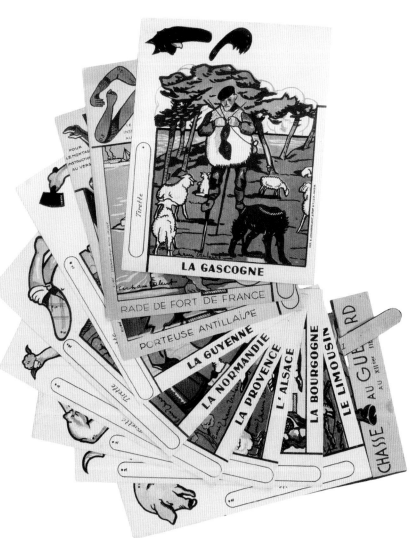

CAT. 22

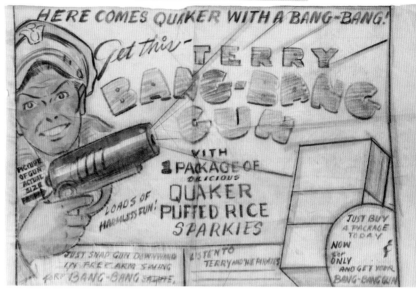

CAT. 23

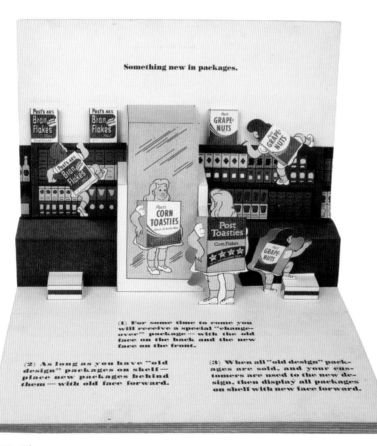

CAT. 24

CAT. 25

22. Lipton Tea. *Thé Lipton: Directement de la plantation à la théière* [*Directly from the plantation to the teapot*], [ca. 1930]. 5⅞ x 4½". Printed in England.

A triple-action volvelle – turn the wheel and the worker picks the tea, factory workers package it, and the teapot lifts to pour the tea.

23. Quaker Oats. *A Terry* [*and the Pirates*] *Bang Bang Gun*, 1938. 13 x 20½".

This tissue-paper prototype advertisement of the premium, the Bang Bang Gun, was drawn in pencil for Quaker Puffed Rice Sparkies. Vitamins were actually "shot" over the cereal as it came down the conveyor belt. Flick your wrist while holding the gun and a triangular piece of paper will fly out, generating an audible "bang" (see cat. 8). The 1930s saw the beginnings of the association between product advertising and popular icons. Cartoon characters, such as Terry and the Pirates and Little Orphan Annie, were serialized on radio and then TV, providing a perfect platform for advertisements. This Quaker Oats prototype is from Sam and Gordon Gold's personal children's premium archive. They were considered the top premium creators during this era.

24. C. W. Post Cereals, Battle Creek, Mich., [ca. 1940s]. 10 pp., 8½ x 11".

This pop-up board book is quite unusual since it is not aimed at consumers but at the product's sales force, namely grocers. Part of the marketing plan is outlined on each page with a parade of young girls dressed in the new cereal packaging. Each cereal will have "its own advertising and promotion." The grocers are instructed on how to display the boxes on the shelves—old ones in front of the new—until the customers are familiar with the new names and boxes. "There's a lot of sales push coming . . . Dreaming, scheming, plotting, planning for the biggest cereal drive in history."

25. Confiserie Roodthooft, Antwerp, Belgium. *Caramella Mokatine*, [ca. 1940s]. 6¼ x 4¼".

The coffee-flavored sweet toffee, Mokatine, also known as Arabier, is the product of Confiserie Roodthooft. Pull the tab to make the card cause a turbaned man to lift his eyes and stick out his tongue to say, "Ah! Ah! *C'est Bon* [*It's Good*]."

26. Wonder Bread, *The Guide to United States Warships*, [ca. 1940s]. 4⅞ x 4½".

Volvelles have been used since the thirteenth century, created as a calendar by Matthew Paris, a Benedictine monk. It is considered the earliest forerunner of computers as it merges information from more than one source. This volvelle shows images of United Nations member country flags and United States warships, helpful during World War II, while at the same time providing information as to how they are named on one side and showing international flag codes on the reverse.
I grew up on Wonder Bread and have never forgotten my class trip to its nearby bakery. I can still recall the glorious fragrance of the factory and thrill of the individually wrapped mini-loaves we could take home.

CAT. 26

27. The Coca-Cola Company, Atlanta, Ga. *Santa Claus Is Comin' to Town: Special edition Pop-up Book*, Volume 1, 1996, 10 pp. 7¾ x 10¼".

The text of this book is the lyrics from the famous 1934 song written by James (Haven) Gillespie (1888–1975, music by J. Fred Coots [1897–1985]). Product placement is prominent on every spread. Message: Santa loves Coke. You should, too.

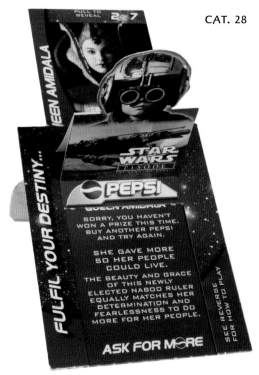

28. Pepsi and Lucasfilm, Ltd. *Star Wars: Episode 1, The Phantom Menace, Fulfil your destiny . . .* , no. 2 of 7, 1999. 5½ x 2½ x 2¼".

One of seven collectible game cards that could be a prize winner from the makers of Pepsi soft drink. In the UK, these were given away in pubs and stores that sold Pepsi. Based on the *Star Wars* movie, pulling the tab causes Anakin Skywalker's image to stand up, revealing a character, in this case, Queen Amidala. It then states whether or not you have won a prize.

29. Arby's, Inc., Atlanta, Ga., *African Adventure Book*, 2000. 8 pp. 3¼ x 5".

One of a series of five pop-up books created by the Arby's fast-food chain to entice children to complete the sets by visiting one of their restaurants. Premiums like this one are also offered by other restaurant chains, such as McDonald's, with their popular Happy Meals.

CAT. 29

30. Chick-fil-A Restaurant. *Eat spicee chikin. Breethe fire* [sic], 2013. 6 x 13".

Pull the side tab and the cow's fiery breath explodes from its mouth. Probably made to stand on the restaurant's table, the reverse shows this fast food chain's chicken sandwich with a glass of Coca-Cola and their signature round waffle fries.

CAT. 30

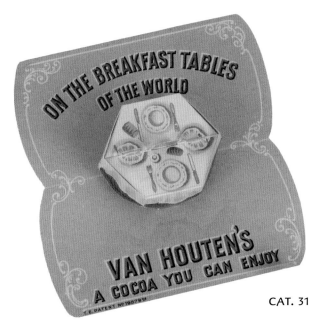

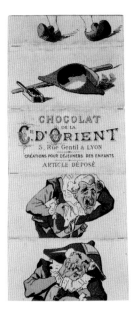

CAT. 31

HATE TOI LENTEMENT

CAT. 32

CHOCOLATE

31. C. J. Van Houten & Zoon. *Van Houten's Cocoa, On the breakfast tables of the world; Van Houten's, A cocoa you can enjoy*, [ca. 1890]. 4 x 4⅛ x 1".

Van Houten cocoa was introduced into the United States from Amsterdam in 1889 and marketed to be added to your breakfast cereal. A table pops up upon opening this trade card laden with images of the cocoa tin and cups of the chocolatey drink. An effective and evocative use of the pop-up!

32. Chocolate Cie. D'Orient, Lyon, France. *Créations pour déjeuners des enfants* [*Children's breakfast creations*], [ca. 1890]. 5¾ x 2½". A. O. L., printer, Paris.

One of a series of what are probably trade card inserts for hot chocolate powder. Each of the three in this collection is color illustrated on paper that folds to change the image. This one is called "une bonne prise" [a good catch], probably referring to the Harlequin containing his sneeze after inhaling snuff. This mechanism, where folding the illustrations at the edge up or down changes the overall illustration, would be called a turn-up book, or Harlequinade, after their common use of Harlequin characters. The turn-up mechanism, developed by Robert Sayer (1725–1794), dates from ca. 1770.

33. Chocolat Guérin-Boutron, Paris. [Aesop's] *Le Lion et le Moucheron* [*The Lion and the Gnat*] and *Artiste Peintre: Peter Paulus 1577–1640*, [ca. 1900]. 5 x 2½". Leopold Verger, printer.

The latter part of the nineteenth century, and well into the twentieth, saw remarkable advances in printing and movable paper elements. Leopold Verger, a Parisian printer, took great advantage of both and produced huge numbers of movable trade cards. These two cards prepared for the chocolate company Guérin-Boutron are well represented in my collection with fifty-one Aesop fables and fifty-five historic fine painters. Their presentation is typical of Verger, with scalloped edges and Art Nouveau flourishes. Verger produced a great many movables for the Au Bon Marché department store. Pull the tab at the bottom of the abridged Aesop fable to reveal the moral of the tale. For the painters' bios, pulling the transformation tab shows their most notable artwork.

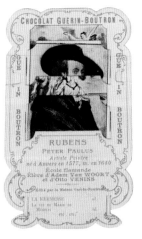

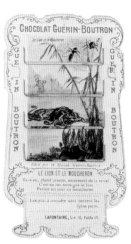

CAT. 33

41

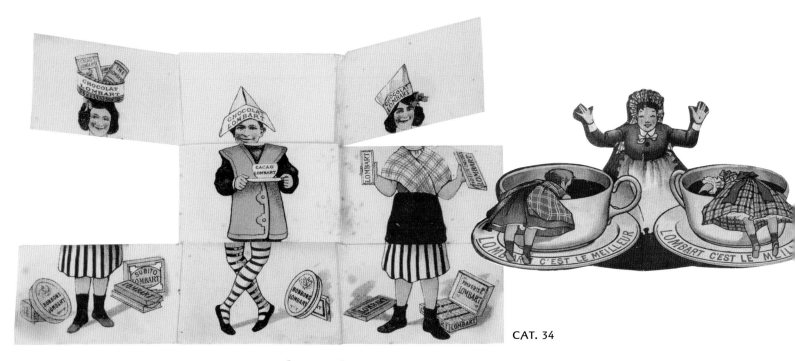

CAT. 34

34. Lombart Chocolat, [France]. *Lombart c'est le meilleur* [*Lombart (chocolate) is the best*], [ca. 1900]. 2¼ x 6″. H. Bouquet, printer, Paris.

Talk about driving home the message. Lombart Chocolat repeats their slogan four times on this double-sided cup-shaped trade card. It may have been included in the package of chocolate as they were known to do. Another Lombart Chocolat premium is a small slice book (ca. 1900, 6 x 5⅞″). Again, every part displays the Lombart logo. It is different from other slice booklets in that it also has flaps at the top and bottom. Bend over the edges to create still other figures.

35. Chocolats Bonnat, Voiron-Chartreuse, France. *Touristes visitez . . .* [*Tourists visit*], [ca. 1940s]. 4 x 2¾ x 1¼″. P. Albert, printer, Rives, France.

Open this trade card to create the diorama that shows the Bonnat and Sons store in Voiron-Chartreuse, France, founded in 1884. The reverse says, *"pour connaitre le secret de faire plaisir, demandez notre catalogue qui vous sera adressé gratuitement et franco"* [to know the secret to please, ask for our catalog which will be sent to you free of charge].

CAT. 35

36. Red October Chocolate, Moscow. *Three Chocolate Pigs* [*Три шоколадных поросенка*], [ca. 1957]. 6¼ x 6¼″.

The very Disney-like characters in this Russian-language pop-up all seem to be enjoying themselves, presumably from having consumed chocolate. This was an insert in the Red October chocolate bar's package. The front image shows three pigs but only two pop up inside, along with the wolf.

CAT. 36

37. Mars. *Discover a thrilling combination,* [ca. 2007]. 10¾ x 16½ x 7".

The 3 Musketeers Mint bar was created to celebrate Mars's 75th anniversary. This advertisement was pulled from a magazine insert showing an actual-sized bar.

OTHER FOODS

38. Kis-Me [sic] Chewing Gum Co., Louisville, Ky. *"Kis-Me" is popular with everybody,* [ca. 1892]. 4¼ x 2⅜".

Lift the tab on the reverse and the shade goes up to reveal the couple smooching, presumably with clean breath. A novelty card like this one could be had for a two-cent stamp and five gum wrappers.

CAT. 38

39. Collection des personnages de Benjamin Rabier. *Animés par les Fromageries Bel Créatrices de la célèbre "[La] Vache qui Rit" - Album no. 1* [The Laughing Cow], [ca. 1930s]. 6⅝ x 17¾". Album by Volumétrix, Lyon and Paris; Chavanne, printer, Paris.

In 1924, Léon Bel, son of a French cheese manufacturer, changed his company's logo to a laughing cow, drawn by illustrator Benjamin Rabier (1864–1939). Bel's marketing savvy encouraged children to acquire printed blotters, book covers, and albums to fill with individual movable cards from Rabier's menagerie. One set of twelve has pull tabs like this one; another has wheels to portray the comical movement.

In a bit of nostalgia, I remember arriving in Paris on my honeymoon unable to speak French. As it was lunchtime when most shops were closed, I shyly went into a food store and asked for La Vache qui Rit, the only French food I could pronounce. My husband and I sat on a bench hungrily opening each wedge of foil-wrapped cheese.

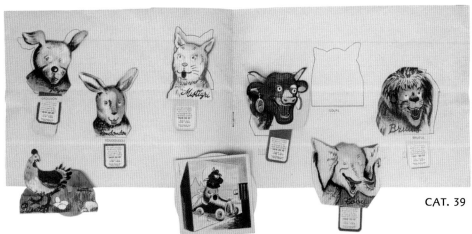

CAT. 39

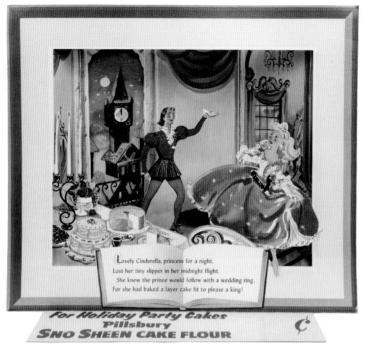

Lovely Cinderella, princess for a night,
Lost her tiny slipper in her midnight flight.
She knew the prince would follow with a wedding ring.
For she had baked a layer cake fit to please a king!

For Holiday Party Cakes
Pillsbury
SNO SHEEN CAKE FLOUR

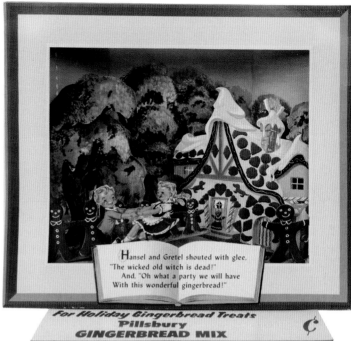

Hansel and Gretel shouted with glee,
"The wicked old witch is dead!"
And, "Oh what a party we will have
With this wonderful gingerbread!"

For Holiday Gingerbread Treats
Pillsbury
GINGERBREAD MIX

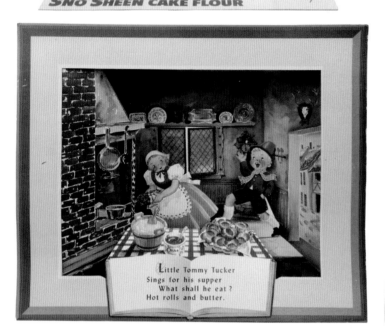

Little Tommy Tucker
Sings for his supper
What shall he eat?
Hot rolls and butter.

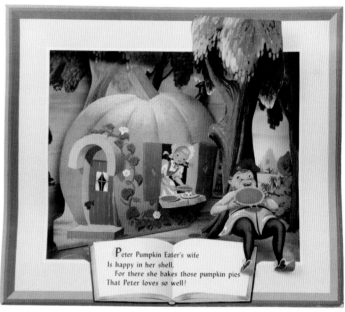

Peter Pumpkin Eater's wife
Is happy in her shell,
For there she bakes those pumpkin pies
That Peter loves so well!

PILLSBURY GINGERBREAD MIX
Hansel & Gretel Diorama
DIRECTIONS FOR ASSEMBLY

PILLSBURY SNO SHEEN CAKE FLOUR
Cinderella Diorama
DIRECTIONS FOR ASSEMBLY

40. *Tom Mix says Eat Ralston, The Straight Shooters Cereal,* [ca. 1935]. 6½ x 4 x 1".

A continuous eight-foot paper reel of black-and-white pictures and text are vertically displayed in the die-cut window when turning the wooden dowels at the top and bottom. The stills are from a 1933 Tom Mix movie, *Rustler's Roundup.* The back of the cardboard "TV" box, called a myriopticon, has an image of Mix eating the cereal with a young boy. At the end of the double reel, Mix gives reasons to eat Ralston cereal and says, "Ask your Mother to get you a box of Ralston" and Ralston "brings the glow of the western outdoors to your cheeks." In addition to his movie career, Tom Mix (1880–1940) stories were also broadcast in radio serials beginning in 1933. A newspaper cartoon series was published as well where premiums, like this one, were advertised and given free in exchange for a coupon from cereal box tops.

41. The Pillsbury Flour Company, Minneapolis, Minn. *"For Holiday Party Cakes-Pillsbury-Sno Sheen Cake Flour": Cinderella, diorama IV,* (ca. 1954). 31 x 28".

In this enormous store display board for Pillsbury flour, Cinderella, running from the prince and losing her slipper, is stepping out of the frame, creating a three-dimensional diorama. A poem ends with ". . . She baked a cake fit for a king." An illustrated kraft paper envelope directs the storekeeper to put the board on top of the flour display and how to pop out the diorama. This series of four displays featuring nursery rhymes includes Peter Pumpkin Eater, Tommy Tucker, and Hansel and Gretel, diorama II (shown here). "Hansel and Gretel shouted with glee, 'The wicked old witch is dead!'"

42. Instant Maxwell House Coffee. *History of Our Presidents,* Graphics International, Los Angeles, Calif., [ca. 1963]. 10 pp., 9¾ x 7⅝"; with the printed mailer.

This was the pop-up publication that launched the Second Golden Era of pop-up books. After advertising executive Waldo (Wally) Hunt saw pop-up books by Vojtěch Kubašta in the early 1960s and was thwarted from importing them from Czechoslovakia, Wally approached Bennett Cerf of Random House publishers. Together they produced a pop-up book premium to be given away with a 14 oz. jar of Instant Maxwell House Coffee. This endeavor was so successful that Cerf went on to publish a large series of Random House pop-up books for children. Wally sold his company, Graphics International, to Hallmark Cards, who also produced a series of pop-up books. Wally then started Intervisual Books, which became the largest packager of movable books in the country.

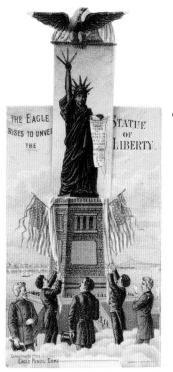

CAT. 43

CAT. 44

CAT. 45

CAT. 46

CAT. 47

Industrial Design and Innovation

43. Eagle Pencil Co., New York. *The Eagle Rises to Unveil the Statue of Liberty*, [ca. 1890]. 7⅜ x 3⅜".

Lift the American eagle on the pedestal and see Lady Liberty rise with a handful of pencils and holding an ad for them. This beautifully chromolithographed trade card also shows the Brooklyn Bridge, completed in 1883, in the background.

44. Keystone Manufacturing Co., Sterling, Ill. *The Keystone Line of Agricultural Implements*, [ca. 1890]. 3½ x 6¼".

Like a rotating catalog, this chromolithographed trade card features a wheel with Uncle Sam demonstrating Keystone's agricultural products. The potential buyers, e.g. Native Americans, Blacks, sheiks, Turks, and Chinese, are the most diverse I've ever seen in an advertisement.

45. Singer Sewing Machines. *Vente annuelle un million de machines* [*One million machines sold annually*], 1900. 4¾ x 5¾". J. E. Goosens, printer, Paris.

The Singer sewing machine, patented by Isaac Singer in 1851, grew into a phenomenal success. It changed women's lives immensely by freeing them from hand sewing, and it gave them experience using machinery and a workshop skill. This chromolithographed trade card, offering a 10% discount, was made for the Exposition Universelle of 1900 in Paris. Printer J. E. Goosens produced numerous movable cards, mostly with v-folds like this one, for Au Bon Marché department store and other companies. Open it to pop up the young women gathered around the machine. In 1900, the cost of a Singer sewing machine started at 90 French francs.

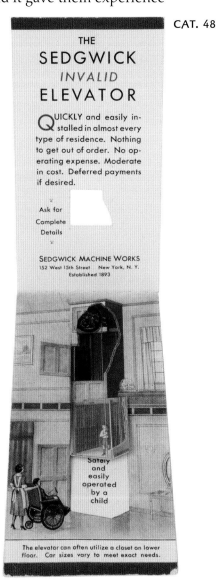

CAT. 48

46. Standard [Furniture Company]. Paris, 1900. 3½ x 5½".

With a pull of the tab, the executive leans back in his chair and the roll top desk cover is lifted by the secretary, clearly demonstrating this feature of the product. The scene is jam-packed with information, which includes Herkimer, New York— "the desk capital of the world"—featured on the map above the desk. Herkimer is where the Standard Furniture Company, founded in 1886, is situated. This French chromolithographed trade card was produced for the Exposition Universelle of Paris in 1900.

47. Trinity Buildings Corp., New York. *High Lights* [sic] *on Lower Manhattan*, [ca. 1907]. 8⅜ x 15¾ x 2¾".

This triptych brochure unfolds to expose two pop-up Trinity Buildings sited on a lower Manhattan map. It goes on to explain in detail the advantages of tenancy and its location, along with floor plans.

48. Sedgwick Machine Works, New York. *For . . . those who cannot or should not climb stairs*, [ca. 1927]. 2⅝ x 10".

Flip up the card and watch the elevator go down. This movable paper design was patented in 1927. The smallest Sedgwick elevator sold for $600 at this time. Another mechanical perfectly reflecting the product it promotes.

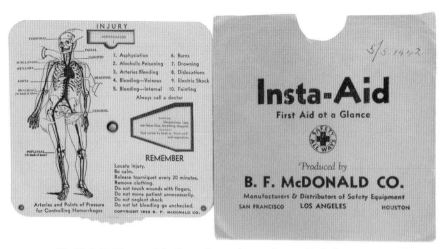

49. B. F. McDonald Co., Los Angeles, Calif. *Insta-Aid: First Aid at a Glance*, 1932. 4 x 4¼".

The B. F. McDonald Co. was a California-based purveyor of safety equipment. It makes sense that they would produce this first-aid giveaway. Double-sided with two die-cut holes on each side of the volvelle, the user could turn to the injury at the top and see the treatment on the side. The skeleton with anatomical landmarks helps. Several other safety equipment companies dispensed the same card with their name and logo on the accompanying sleeve.

50. Waterman's Ideal Fountain Pen. *Waterman's for Speedy Writing*, [ca. 1930s]. 5¾ x 6⅝".

This lithographed advertising card shows a man buying a Waterman's pen. Open the card and he pops up and spins around to his desk in his office. The "Famous No. 52" pens are shown and described on the reverse.

51. Tesla Radios, Czechoslovakia. *What do we need to add to our contentment? A Tesla radio!*, [ca. 1957]. 4¼ x 9". Vojtěch Kubašta, paper engineer and illustrator.

Communist Czechoslovakia was determined to become a major industrial nation that would turn out varied household products. This English-language advertising card shows an upscale sophisticated couple wanting more consumer goods, like the Tesla radio. Pull out the tab and see the radio, the list of the radio's attributes, and the answer to their question.

52. *A reliable helpmate of the modern woman: Lada Sewing Machine*, [ca. 1950s]. 6⅞ x 8¼ x 4½".

One of the many pop-up advertisements that Czech graphic artist and paper engineer, Vojtěch Kubašta, devised to present a clear and dynamic message for a Czech manufacturer. Open the card and two pop-ups show the before and after of women sewing, drudgery versus ease.

Printing and Publishing

53. Coshocton Specialty Co., Coshocton, Ohio. *Space For Advertisement*, [ca. 1910]. 3½ x 5½".

Bend the end of the divided-back postcard, as instructed, and the two figures in the boat will kiss. Employing the *moiré* technique, movement is created on the card. This printing company, using the A. S. Spiegel patent, will put an advertiser's logo and/or name on the front.

54. Economy Novelty & Printing Co., New York. *Paramount Theatre, Harold Lloyd: Bring the Family: A picture for kids from 6 to 60*, 1932. 6⅝ x 3⅞".

This ad for Harold Lloyd's new film, *Movie Crazy*, also serves as a sample of movable trade cards printed by Economy Novelty. The wheel turns Lloyd's arm, which appears to be erasing the name of the movie. The reverse urges you to *"Turn the disc on other side and imagine all your patrons doing likewise,"* and lists the costs of printing this kind of card, e.g. 25,000 at $10 per 1000. This is one of the more unusual and versatile mechanical promotional devices and is quite interactive. I have not seen it offered in other printers' catalogs.

55. The Pop-Up Book Club. Grolier Enterprises, Danbury, Conn., [ca. 1968]. 8 x 5½".

This announcement for a new line of children's books delivers a premium in the form of a BLAD [book layout and design], recreating a single spread from a new pop-up book, in this case, *The Animal Alphabet* (1967). The brochure, housed in an illustrated "must open" envelope, offers a discount for two editions in a new subscription series of pop-up books when sending in the enclosed token. Although unstated, the books shown are from the Random House series that inaugurated what the Movable Book Society calls the Second Golden Age of Pop-up Books. The text boasts, "This is reading adventure even television can't beat!" (Grolier Enterprises is not affiliated with the Grolier Club.)

56. Mohawk Paper Mills, Cohoe, N.Y. and The Pushpin Group, New York, N.Y. *Design & Style No. 3: Paris Deco*, 1988. 24 pp., 12 x 10".

Founded by Seymour Chwast, Milton Glaser (creator of the "I Love NY" logo), and Edward Sorel, The Pushpin Group published a series of expository booklets demonstrating different graphic styles. This one, using examples of cardstock and foil from Mohawk Paper Mills, includes a pop-up of the Eiffel Tower. Also included is an illustrated DIY card to cut out and create a box for Marcel Waving Gel, which allowed women to style their hair with "undulating waves," a popular Art Deco fashion of the '20s.

CAT. 53

CAT. 54

CAT. 55

57. Robert Sabuda and Matthew Reinhart. *Encyclopedia Prehistorica: Dinosaurs*. Somerville, Mass.: Candlewick Press, 2005. 9½ x 7½".

BLADs are made to promote the sale of pop-up books to publishers and stores. It is a single spread, including the pop-ups and artwork, as it will appear in the final copy. Sabuda and Reinhart were a dynamic duo of paper engineering, producing several movable books printed in the hundreds of thousands. They continue to work individually today. Sabuda was the first to use photo corners to hold gatefolds (i.e., flaps with pop-ups or text underneath) to the page in his *Wizard of Oz* (Little Simon, Simon & Schuster, 2000).

 I like to think that when I challenged Robert in 1993 to expand the text in pop-up books, and he said it couldn't be done, he then came up with the solution shown here, flaps held down with photo corners.

CAT. 57

50

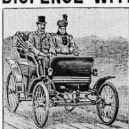

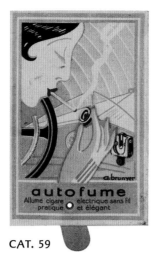

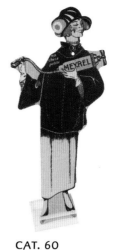

CAT. 58 CAT. 59 CAT. 60 CAT. 61

Automotive

58. The Winton Motor Carriage Co., Cleveland, Ohio. *Dispense with a Horse*, in *Scientific American*, September 3, 1898.

The first advertisement for the horseless carriage appeared in the July 30, 1898 issue of *Scientific American*. Its main pitch pointed out the benefits of the motor car over the horse by highlighting the horse's negatives, e.g. odor, cost of upkeep, and slowness.

59. M. Poyet & Co., Paris, France (wholesaler). *Autofume. Allume cigare électrique sans fil pratique et élégant* [*Autofume. Practical and elegant cordless electric cigarette lighter.*], [ca. 1920s]. 5 x 3".

Move her hand and she "lights" her cigarette. This trade card for an automobile dashboard-mounted cigarette lighter has a full description and wholesale prices on the reverse.

60. Meyrel Motor Oil, Clichy, France, [ca. 1920s]. 6 x 2¾". H. Bouquet, printer, Paris.

Shaped color-printed chic woman with a movable head holding a grease gun. Reverse with printed advertisement.

61. Shell Motor products. *Wow! That must have been Shell, the gasoline for PEP and POWER*, [ca. 1920s]. 5¾ x 5". The Regensteiner Corp., printer, Chicago.

CAT. 62

Pull the cardstock side panel and the police officer's head swivels 180°. An advertisement for several Shell products appears on the reverse.

62. Tudor [auto-batteries, France]. *Demarrez . . . sûrement et sans perte de temps avec les batteries Tudor "Puissante".* [*Get started . . . safely and without wasting time with Tudor "powerful" batteries*], [ca. 1930]. 4 x 5⅞".

Cut out and assemble the printed parts to make the card movable. DIY cards were an economical way to have the consumer interact with the product and save on the costs of hand-assembly. Founder Henri Owen Tudor (1859–1928) developed the first lead-acid battery in 1886 and died of lead poisoning. (Shown with an unassembled card.)

CAT. 63

63. Cupp Bros., a Ford Sales & Service Station, Mifflintown & Lewistown, Pa., *Souvenir [of] Juniata County Centennial 1831–1931*, 1931. 8½ x 13".

A three-slat fan illustrated on the front with a pleasant family beach scene. There is text advertising the service station and its locations on the reverse. This fan could be offered to other businesses as an advertising promotion.

CAT. 64

64. Standard Oil Company of California. *Standard Gasoline-Winter Freeze Tested*, 1932. 5¼ x 4¼".

Shake the polar bear-shaped trade card side-to-side and metal, concealed in its paws, has it banging on a drum with a wooden center that's printed with the company's ad.

65. Pontiac, a division of General Motors Corp. *Pontiac Value Comparison: A slide guide of motor car values*, [1934]. 4½ x 14½".

Pulling out a double-sided card under a die-cut slot reveals a comparison of features of twenty-two different cars against three models of 1934 Pontiacs. Besides the usual car specifications (e.g., length, weight), comparisons are made of the brakes, hydraulic systems, and location of the emergency brakes. List prices are also noted. A great deal of information is packed in a small space.

CAT. 65

CAT. 66

66. Esso Motor Oil, 1946. 5¼ x 3½".
A "magic wallet" movable with black and white photos. An unexpected opening from both sides of the card presents different text and images.

67. The Cracker Jack Company, Chicago, Ill. *Cracker Jacks Midget Auto Race*, [ca. 1940s]. 3⅜ x 2".
Spin the cardboard wheel with five numbered automobiles and you win when your number stops over the arrow on the base page. One of hundreds of movable Cracker Jack prizes. We all dug for the prize at the bottom of the box. How many of us saved them?

68. Esso Motor Oil, [France]. *Faire de la corde raide, Monsieur Souffran est chose dangereuse ..., [Tightrope walking, Monsieur Souffran, is a dangerous thing ...], [ca. 1950s]. 7 x 16".
A five-panel panoramic color advertising brochure with a figure hanging on a string and v-fold gas station with its business address. Monsieur Souffran is a recurring character in a series of Esso Motor Oil printed movable advertisements with space to add information for different individual gas stations.

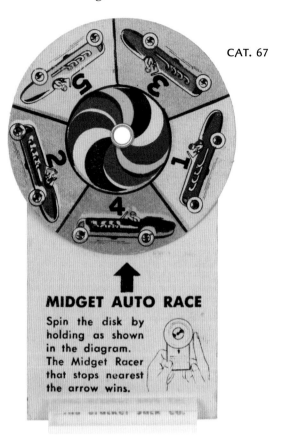

CAT. 67

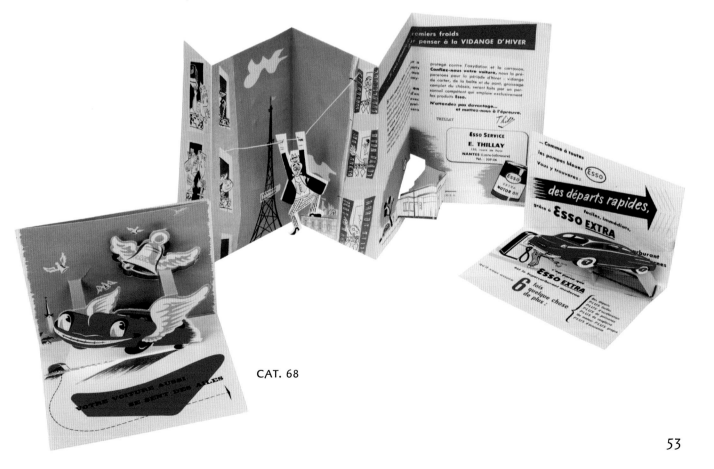

CAT. 68

69. Nissan Motor Company, Ltd. *Nissan Pickup Pop-up Book,* [ca. 1986]. 12 pp., 7⅜ x 10⅜".

Nissan celebrated the launch of its newest pickup truck using the benefits of a pop-up book. Pulling the tabs allows the user to see how the doors open, the air conditioning gets distributed, and the flat bed folds down. The pop-up recreates the engine with its specs.

70. Ford Motor Company, Dearborn, Mich., in association with the Children's Television Workshop (CTW). *National Safety Tour-Buckle up with Sesame Street,* 1998. 11¾ x 26½".

The triptych opens to a pop up of Big Bird and Mr. Hooper's store. The folder's pocket contains: a three-page press release announcing a program to teach auto safety to children and parents; a copy of *CTW Sesame Street Parents* magazine, sponsored by Ford, with general safety tips; a pictorial double-sided color card insert, *Safety Advice*; and a photo slide in a separate pocket, *Sesame Street and Ford Teach Safety*. This is an uncommon example of a promotional piece in the public interest.

CAT. 70

71. Lexus, a division of Toyota Motor Corp., Japan. *The Safest Accident: A precautionary tale by Lexus*, 2007. 6 pp., 9 x 11". Roger Culbertson, paper engineer.

A pop-up book based on the TV commercial, highlighting the safety features of the Lexus. Bound in paper-covered boards, it has several mechanicals. A letter to the dealer states the pop-up book was "handmade using the actual visuals and script from the television commercial and goes on to say that "these books are a creative approach to reach consumers and their children." A DVD of the commercial is provided in a rear pocket and may also be viewed on YouTube at https://bit.ly/3sQhYIR.

72. Toyota Motor Sales, USA. *The 2018 Camry*, 2018. 10½ x 7½" (closed); 10½ x 28" (opened).

Fifty thousand glossy, battery powered ads were inserted into the March 2018 issue of *InStyle* magazine for subscribers only. It is surely one of the most technologically ambitious advertisements ever devised. Fold back the gatefolds and put your thumbs on the metal discs of the simulated "door handles" while opening the ad further. The new Camry dashboard appears with a pop-up steering wheel and, amazingly, the user's *actual* EKG reading moves across a screen. The intent is to show the user's excitement by displaying an increased heartbeat. The ad also releases a new car smell.

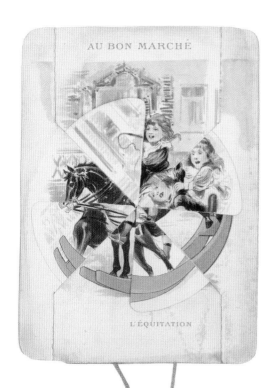

Promoting Business

73. Au Bon Marché Department Store, Paris. *Cendrillon* [*Cinderella*] and *L'Équitation* [*The Horseback Rider*], [ca. 1900]. 3½ x 3¼ x 2" and 5¾ x 3¼".

It is unlikely there was any mercantile establishment that produced more chromolithographed trade cards (or "chromos") than Au Bon Marché. It is reported that from 1895 to 1914, the department store distributed 50 million chromos, each with a circulation of between 100 and 400,000 copies. The movable ones are of the highest quality and complexity. Cards were given out free to customers, especially on Thursdays, when there was no school. There would easily be cause for excitement in acquiring these, such as the fairytale theater series *Cendrillon*, in a set of six, where the roof holds the diorama open to allow a view into the tableau and the cellophane moon when lit from the rear. Another was a dissolving disc card like *L'Équitation*, in a set of four. Pull one string and the "blades" circle over each other to expose another chromolithographed image. Many of these cards advertise the 1900 Exposition Universelle in Paris that extolled new inventions and ideas in France and countries from around the world. With their elaborate mechanicals, it is easy to understand how these cards have survived to this day.

74. Wanamaker Store, Philadelphia, Pa., [ca. 1910]. 3½ x 5¼ x3½".

This is probably the strangest item in this collection. This postcard advertising Wanamaker's new store in Philadelphia instructs the recipient to "blow here" into a hole over your address. Blow and a crepe paper replica of the new building will expand out.

75. Aux Galleries Lafayette, Paris. *Le Loup et L'Agneau* [*The Wolf and the Lamb*], [ca. 1912]. 3⅝ x 3½ x 1¾".

Aux Galleries Lafayette must have seen its potential customers and other people flocking to Au Bon Marché and receiving the chromos. These cards, based on Aesop's Fables, are rarer than those issued by Au Bon Marché, perhaps because many printing houses and their presses, mostly in Germany, were destroyed during World War I and the scrapbooking era was waning.

LE LOUP ET L'AGNEAU

76. Miles L. Eckert and Son Insurance, Allentown, Pa. *Do you know what your property is worth today? Property Valuation Chart,* 1922. 3½" dia.

To estimate the replacement value of your home or business and its insurance value, turn the wheel to the year it was built—up to 1922—and the answer is given. The reverse gives an example in case the instructions are not clear.

77. *Talking Postcards.* Red Oak, Iowa: The Thomas D. Murphy Co., [ca. 1924]. 13 x 19".

To make a sale, you must show your client what they are buying. This salesperson's folder contains several sample postcards. Each card opens to create a character with a v-fold mouth and generic "stories" relating to the character, all customizable by the client. The inside text presumably can include the client's pitch, logo, or company information.

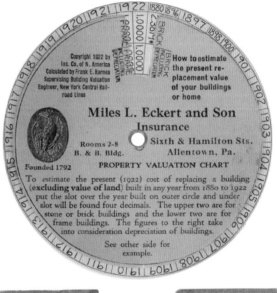

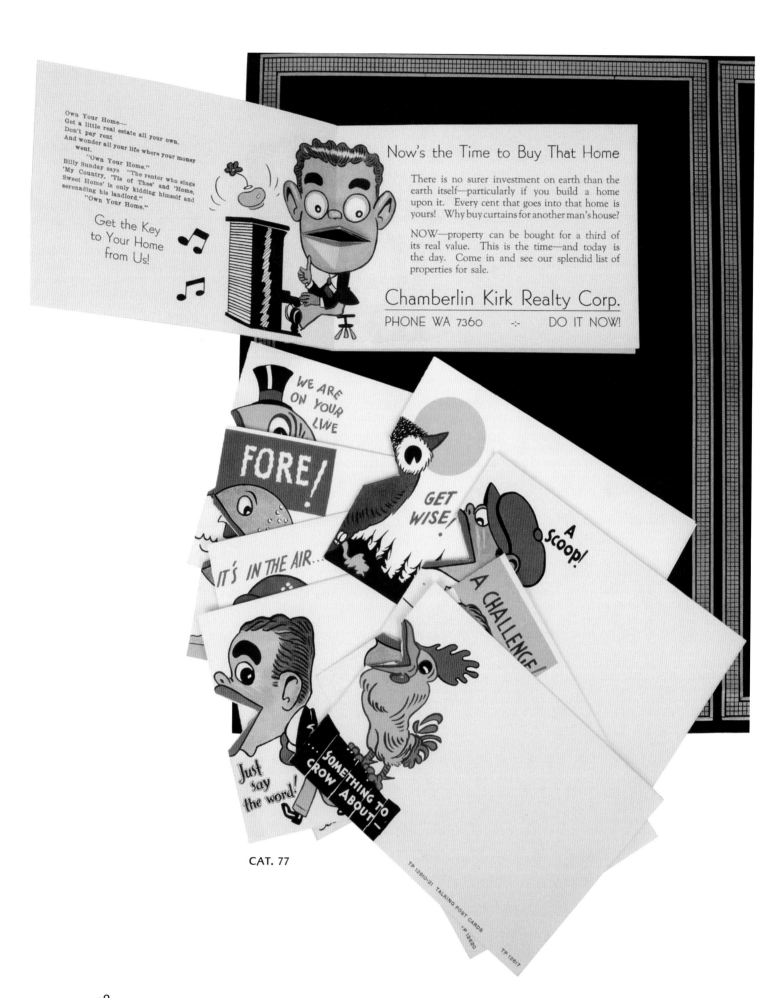

Own Your Home—
Get a little real estate all your own.
Don't pay rent
And wonder all your life where your money
went.
 "Own Your Home."
Billy Sunday says "The renter who sings
'My Country, 'Tis of Thee' and 'Home,
Sweet Home' is only kidding himself and
serenading his landlord."
 "Own Your Home."

Get the Key
to Your Home
from Us!

Now's the Time to Buy That Home

There is no surer investment on earth than the earth itself—particularly if you build a home upon it. Every cent that goes into that home is yours! Why buy curtains for another man's house?

NOW—property can be bought for a third of its real value. This is the time—and today is the day. Come in and see our splendid list of properties for sale.

Chamberlin Kirk Realty Corp.

PHONE WA 7360 -:- DO IT NOW!

CAT. 77

58

78. 松坂屋 上野店 [Matsuzakaya Department Store], Ueno, Japan, [ca. 1930]. 4¾ x 7⅜″.

The Matsuzakaya Department Store was founded in 1611 and is the oldest chain store in the world. When the store in Ueno was updated, a guide to it was printed in paper layers. Each of the eight layers show, in line drawings, what can be found on that floor.

79. Sears, Roebuck and Co., Chicago, Ill. *Sears, Roebuck and Co. at the Century of Progress, International Exposition,* 1933. 16 pp., 7¾ x 10⅞ x 2¼″.

Images of Sears's automated package-sorting system in this paper brochure, printed for the 1933 Chicago Century of Progress Exposition, looks like a latter-day Amazon warehouse operation. The building for the fair, shown as a patented pop-up in the brochure, used "stagecraft" to portray Sears's merchandising and marketing strategies. The emphasis on service was demonstrated by the amenities in the building housing the Sears exposition, which are described when the pop-up folds down. Among those amenities are phone booths, a café, and a telegraph office.

CAT. 78

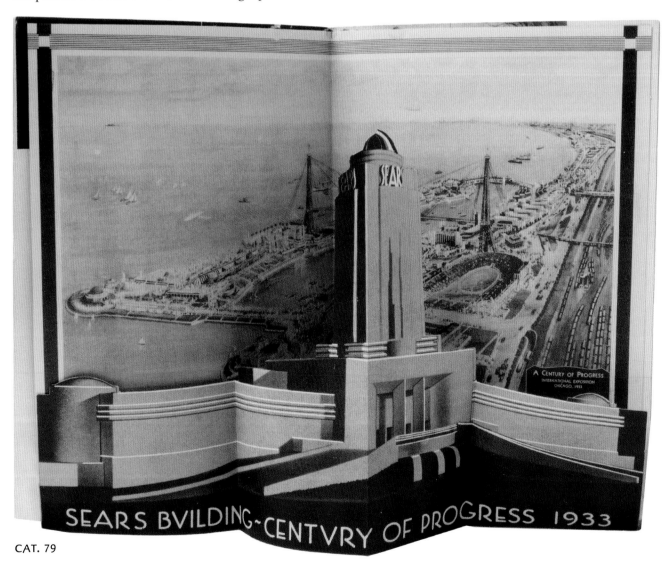

CAT. 79

CAT. 80

80. Société des Colonies de Vacances de la Mission Populaire [Society of Popular Mission Summer Camps], [France]. *De joyeuses vacances au soleil et au grand air, voilá leur réve . . . aidez-nous à le réaliser! "Soleil et santé"* [Happy holidays in the sun and the great outdoors; Here is their dream . . . help us to realize it! "Sun and health"], [ca. 1930s]. 5¾ x 4⅛".

Sign up for this summer camp for 8 francs per day and have the child enjoy a host of activities. Just turn the wheel to see the activities offered.

81. *Out of Sight-Out of Mind . . . Save your roof and you save all!* Ft. Worth, Texas: Panther Oil & Gas Manufacturing Co., 1946. 8 pp., 8 x 10½".

One of the more unusual sales promotion pieces, especially with the use of a plastic tab that allows for a double-page presentation per spread. The pop-up book makes a strong visual case for Panther's patented "Battleship" roofing coating. An image of Uncle Sam proudly displaying the patent appears on the rear cover.

CAT. 82

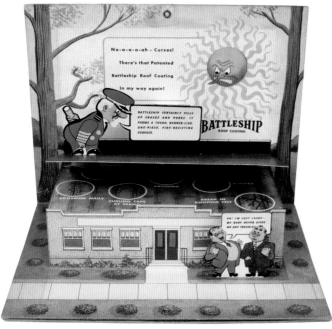

CAT. 81

82. First National Bank of Arizona. *For boys and girls*, [ca. 1960]. 8 pp., 6½ x 4". Patti Roberts, illustrator.

First National Bank encourages children to save their money and then deposit it to their bank. This booklet with several movables has a poem that tells of Bobby and his sister, Monique. Monique saves her money and buys Christmas presents for the family and Santa. Bobby spends his funds on candy. Santa sets Bobby straight on Christmas Eve by saying, "The best part of Christmas is giving."

83. Státní Spořitelna [State Savings Bank], Czechoslovakia. *Vkladní Knížka Pomůže . . . Splnit Vaše Prání* [Passbook Will Help . . . Fulfill Your Wishes], [ca. 1960s]. 6 x 15½ x 1¾". Vojtěch Kubašta, paper engineer and illustrator, Prague.

True to his genius, Vojtěch Kubašta uses his architectural and graphic arts talent to cram a great deal of information into this card. Pull open the pop-up to see the financials for mortgage or building construction loans. Kubašta began inserting pop-ups into his advertising designs in the late 1950s.

84. Jan Pieńkowski. *Haunted House: Intervisual Books 1992 Annual Report.* Los Angeles, Calif.: Intervisual Books, 1979. Report, 24 pp.; pop-up book, 12 pp.; 12 x 7¾".

Haunted House was one of the most successful pop-up books ever, selling one million copies. It won the 1980 Greenaway Medal and a second Greenaway Medal for Pienkowski. It was creative genius to use the award-winning book as part of Intervisual's annual report, making it a collectible and promoting their success while demonstrating a sample of the company's product.

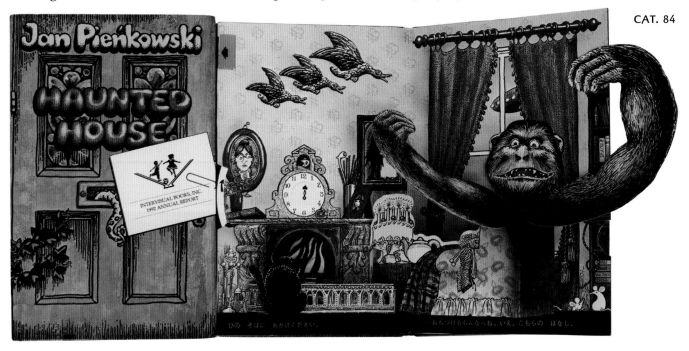

CAT. 85

85. Transamerica Insurance, San Francisco, Calif. *Would the most innovative insurance company in America please stand up*, 1986. 10¾ x 16 x 8¾".

Just one year after Honeywell Corp. created the first magazine pop-up insert ad, Transamerica followed suit with an ad of their iconic Pyramid Headquarters building in San Francisco. The ad stands over 8" tall. Over 5 million copies were printed and inserted into the September 8, 1986 issue of *Time* magazine. Costing $3 million, 35% of Transamerica's advertising budget, and using 420,000 assembly worker-hours in Latin America, this record-breaking insert was noticed and written about: a Transamerica survey revealed a 90% recall of the ad.

86. *Eskimo Pie 1993 Annual Report: The Cold Facts*. Richmond, Va.: Eskimo Pie Corp., 1993. 24 pp., 11½ x 8¼".

Annual reports can be quite dry but the version produced by Eskimo Pie grabs its readers' attention by simulating its product. The design mimics a chocolate-covered ice cream pop that holds a booklet within. Remove the "chocolate" sleeve and the report is revealed, mounted on the popsicle stick.

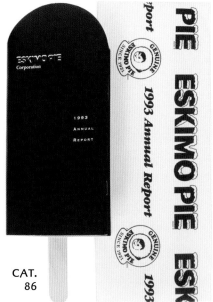

CAT. 86

87. Structural Graphics: Up with Paper, Essex, Conn. *The Architects of Paper*, 1997. 12 x 9".

Structural Graphics (including its Up with Paper greeting card division) is a titan in the field of dimensional marketing. Using standard paper engineering mechanisms while creating new ones, this folder demonstrates how they command the consumer's attention with movable paper structures. Here they use three pop-ups and photographs of their innovations.

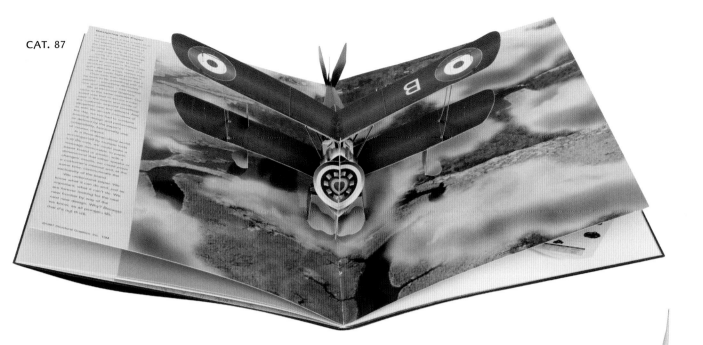

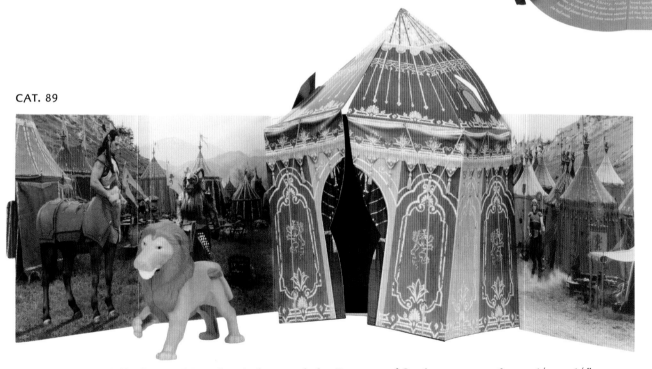

88. Sonic Corp., Oklahoma City, Okla. *Sonic Wacky Pack. Molly's Favorite Places*, 2000. 4 x 4".

Started in 1996, Sonic is another fast-food restaurant drive-in chain that also catered to kids with promotional toy giveaways. Get a free toy with each child's meal. *Molly's Favorite Place* is one of a set of four in carousel book format. Open the ribbon tie and pull back the covers together to form a structure in the round with additional pop-ups inside. Several of Sonic's toys, like this one, also emphasized the benefits of reading.

89. McDonald's Corp. *Narnia: Aslan and the Return of Spring*, 2005. 6 x 21¼ x 3⅛".

Continuing their very successful Happy Meals promotion that brought children into the restaurant to complete the promotional sets of giveaways, McDonald's created a series of eight pop-up booklets with images and plastic figurines from the Disney movie, *The Chronicles of Narnia*.

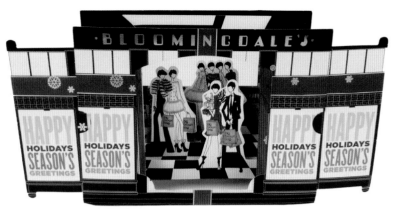

CAT. 90

90. Bloomingdale's Department Store, New York. *Happy Holidays Season's Greetings*, [ca. 2010]. 4 x 7 x 2".

Every Christmas and Chanukah, Bloomingdale's cash registers display holiday greeting cards. Inside are gift cards awaiting monetary assignments at purchase. For several years, these cards used inventive paper-engineered images, making the card a keeper. In this example, a theater set-up, the user pulls the side panels and a stage appears. Of course, this stage is filled with shoppers, each toting a Bloomingdale's signature "My Brown Bag" in a replica of the flagship store's first floor.

91. Bret Blizzard and Michael Voelker. *Acuity's Storybook Year: Annual Report 2010.* Sheboygan, Wis.: Acuity, 2010. 12 pp., 10¼ x 8¼". Aaron Boyd, illustrator.

By far the most complicated annual report ever produced is the one for Acuity Insurance Company. The complex pop-ups, paper engineered by Andrew Baron, explode from these pages while reporting the company's accomplishments with nursery rhymes. The actual financial information is given in small booklets mounted on every page. Over 19,000 copies were produced and distributed to the firm's insurance agents, some of whom were reportedly outraged by the cost. The design garnered many awards and this annual report was added to the collections of the Smithsonian Institution Libraries.

92. *M Restaurants 2015 Diary*, 2015. 8¾ x 8½".

This is an extraordinary linen-covered one-year diary packed with movables and pop-ups, an apron, maps, and postcards. It represents a chain of Chinese restaurants in Beijing, Shanghai, Hong Kong, and Yangon. In English and Chinese.

CAT. 91

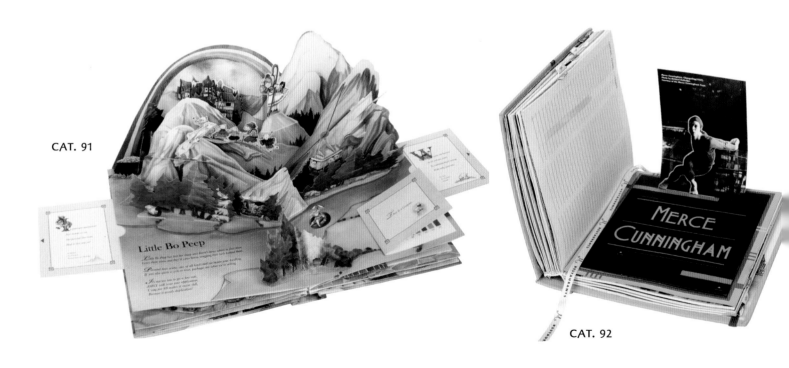

CAT. 92

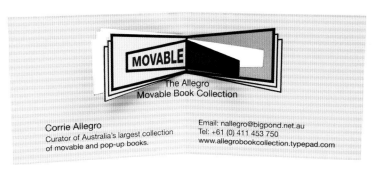

CAT. 93 CAT. 94

BUSINESS CARDS

The items in this section cover personal movable business cards issued by paper engineers, artists and other individuals in related fields.

93. *Corrie Allegro*, paper engineer and collector.

The Allegro Movable Book Collection, Australia. Opened die-cut card has a free-floating tab printed, "Movable Books." 2⅜ x 6¾".

CAT. 95

94. *Peter Daugaard*, bookseller.

Antikvariat, Stege, Denmark. Card opens vertically to reveal printed fan-folded book spines. 4⅝ x 3½".

95. *Joe [Freedman]*, paper engineer.

Pull the card out of the paper sleeve with a die-cut hole and it opens to form an x-shaped cut-out structure with floating red paper "pepper". 2 x 3½".

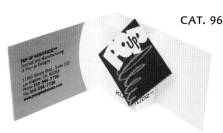

CAT. 96

96. *Guillermo Holguin* (1944–2004), printing entrepreneur.

Pop-up Kukurudz, Key Biscayne, Fla.; France. Card opens sideways, causing the company logo inside to rotate 45°. 2¼ x 7". Guillermo, born in Calí, Colombia, worked for Cargraphics in South America, producing the best classic pop-up books from 1968–2000.

I had the pleasure of working with this knowledgeable and courtly gentleman in Ecuador during the assembling of *Brooklyn Pops Up* (2000), published for the exhibition mounted at the Brooklyn Public Library. Holguin finished his career at Kukurudz, a three-dimensional advertising company based in France.

CAT. 97

97. *Erik Hluchan*, Creative Director, Structural Graphics, Essex, Conn.

Break thru at STRUCTURAL GRAPHICS. The flexagon format here can show multiple surfaces depending upon how it's folded. 4⅜ x 3½".

CAT. 98

98. *Kelly M. Houle*, paper engineer.

Books of Kell's, artist, author, illustrator. Gold-stamped historiated letter B on the cover opens to anamorphic art with a pop-up mylar strip. 4" x 3½".

CAT. 99

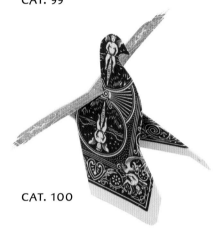
CAT. 100

CAT. 101

CAT. 102

CAT. 103

99. *Giovanni Iafrate*, paper engineer.
Semi-circular card printed like an apple slice and featuring a real apple stem. Red paper bellows expand on the side. 2⅝ x 1¾ x ½".

100. *Sam Ita*, paper engineer.
www.samita.usa. Standard playing card folds into an eagle. 3½ x 2½".

101. *Robert Kelly*, paper engineer, artist and inventor.
I can make that. robkellydesign.com. Pull-out the card to cause a printed box to pop up. 2 x 6".

102. *Yoojin Kim*, paper engineer, printmaker, designer and book artist.
The card is printed on the outside with animal bones and opens to form a pop-up human rib cage. 2 x 4"; in glassine envelope.

103. *Courtney Watson McCarthy*, paper engineer.
Opening the card causes the pull tab, labeled *Off Center Pops*, to move in and out of a popped-up circle. 2 x 6½".

104. *Kyle Olmon*, paper engineer.
Kyle Olmon. Pulling the tab with the domain suffix ".com" causes the word "pop-ups" to pop up and complete his web address. 2 x 3½".

105. *Frank Ossman*, pop-up advertising executive (retired).
Vice President, Structural Graphics, Inc., Essex, Conn. A three-dimensional printer pops up when the card is opened and simulates the paper coming out. 4⅜ x 3½". Structural Graphics is a leading company specializing in three-dimensional promotional and interactive advertising.

106. *Adie C. Peña*, paper engineer and collector.
Museo Mobiblio, Makati City, Philippines. Signed "Adie," this limited edition (no. 5 of 36) card opens sideways to reveal a pop-up facsimile of the book bag Adie gave as a gift for the Movable Book Society's 3rd Conference, September 21, 2000, in New York City. 3¼ x 8". Adie created Museo Mobiblio to house his collection of pop-up books. The card is inscribed [to The Popuplady], "I look forward to seeing your collection one day."

107. *Anton Radevsky*, paper engineer.
Paper Design. Sofia, Bulgaria. Interlocking card flaps open to display business information. 1⅞ x 7⅛".

108. *Ellen G. K. Rubin*, collector, writer and curator.
The Popuplady, Specializing in Movable Paper. Open the booklet to cause The Popuplady's original logo to stand up from a book-like page. The biographical information is handwritten on a stickie and affixed to the front. Andrew Baron, paper engineer. 3½ x 2".

66

CAT. 104

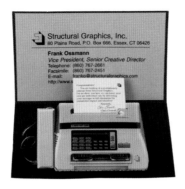

CAT. 105

CAT. 106

109. *Joel Stern*, origami artist.
Printed folded paper opens to reveal a pop-up face inside. 3¼ x 8".

110. *Colin Roy Todd*, illustrator and paper engineer.
colinroytodd.myportfolio.com. Double-ply card opens to a pop-up alligator. 4 x 3½".

111. *Isabel Uria*, paper engineer.
Paper Design Paper. Coated pouch (3" dia.) with interlocking lens-folded die-cut closures opens to reveal a white origami mini-spider inside. Separate business card, paperdesignpaper.com. 1½ x 3⅞".

112. *Yevgeniya Yeretskaya*, designer and paper engineer.
Director of Paper Engineering at Up with Paper and Jumping Jack Press, Guilford, Conn. Card opens to present a pop-up of a woman with butterfly wings. 4 x 3½".

CAT. 107

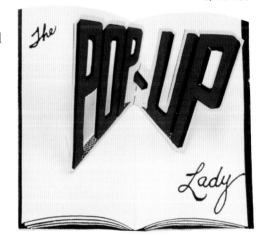

CAT. 108

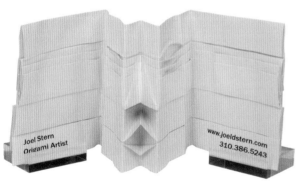

CAT. 109

CAT. 111

CAT. 110

CAT. 112

67

CAT. 114

CAT. 116

Alcoholic Beverages and Tobacco

113. Stulz Bros. [Whiskey], Germany and Kansas City, Mo. *Stulz Bros. Of Course*, [ca. 1890s]. 4¼" dia. Willy Mayer & Co., creator, New York.

"Form this into four pictures" is the challenge on the outermost spoke of this six-part wheel. Five color-illustrated spokes are each printed with two parts of an image. Rotate the five spokes to form two images and use the outermost one to cover the rest. A true challenge. Closed, it resembles a bowtie with the advertisement on it.

114. Michel Jacquemont, Lyon, France. *L'Immortel Quinquina Apéritif Tonique*, [ca. 1900]. 5 x 6⅜". J. E. Goosens, printer, Paris.

Open this trade card with the die-cut lovers sitting on the grass and see the gentleman offer his companion a cup of the advertised spirits, derived from quinine. A short poem by "M. J." tells you this cup of wine will put love in their future. J. E. Goosens was a very popular chromolithographer at this time.

115. Dubonnet, [France]. *Sous tous les climats . . . Un Dubonnet reconstitue* [*In all climates . . . A Dubonnet restores*], [ca. 1931]. 7 x 5¼".

Probably produced as a giveaway, for the Paris Colonial Exposition (May 6–Nov 15, 1931), the explorer gets fortified by drinking Dubonnet. The story is told with each '"segment" appearing in the die-cut hole when the wheel is turned.

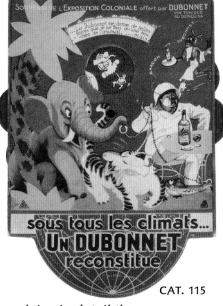

116. Seagram Distillers, New York. *The House of Seagram: Integrity, Tradition, Craftsmanship*, [ca. 1954]. 13½ x 10½".

Anticipating the New York City Seagram Building's completion in 1957, this linen-covered book recounts the history of the Seagram's company and explains in detail the big improvements in all its products, the intended audience being its sales force. Even poet Robert Browning is quoted about man's reach for heaven. The final spread with three pop-up Seagram's bottles lauds the solution to the "decanter problem" as nothing less than "a designing and production miracle."

117. Renfield Importers Ltd., New York. *From all over the world . . . Renfield brings you the Finest*, [ca. 1955], 5½" dia.

The front of this volvelle is printed with the bottle labels from liquors distributed by Renfield. Turn the wheel and the salutations, "hello," "goodbye," and "to your health" are seen in the languages of seventeen countries printed around the periphery. On the reverse is an advertisement for Pan American World Airways. Point the arrow to one of the same seventeen countries and see how many hours it takes to get to an airport using Pan Am's new DC-7C airliner.

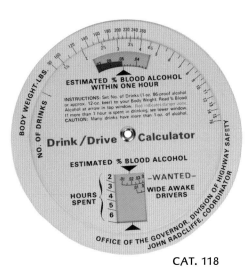

CAT. 118 CAT. 119

118. Governor's Traffic Safety Coordinating Committee, Springfield, Ill. *Wisconsin wants you to live: Remember the best idea still is "When you drink, don't drive,"* 1971. 3¾" dia.

Match your body weight to the number of drinks you've imbibed to calculate your blood alcohol level on this volvelle. The reverse explains the effects of the calculated blood alcohol levels on the body.

119. Martini & Rossi Wine Co., Coral Gables, Fla. *Discover taste for every occasion,* 2015. 6" dia.

Wine pairings are made easy with this double-sided volvelle that shows what wine to serve with each entrée and cheese for every occasion.

120. Philippe Huger [UG], *Louis Jadot,* Burgundy, France, [ca. 2020]. 8 pp., 11¾ x 11⅞". Limited edition of 200 copies plus twelve lettered copies, this being copy F.

Devoted to the Louis Jadot winery, started in 1859, paper engineer Philippe Huger, known as "UG," created by hand a brightly colored cardboard pop-up artist's book, without text, to visually tell the story of the winery.

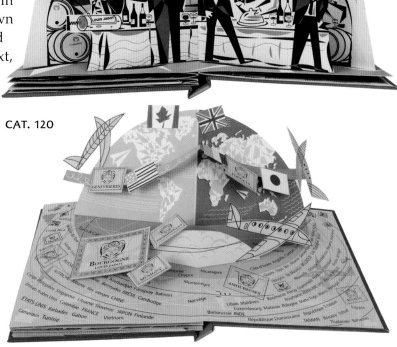

CAT. 120

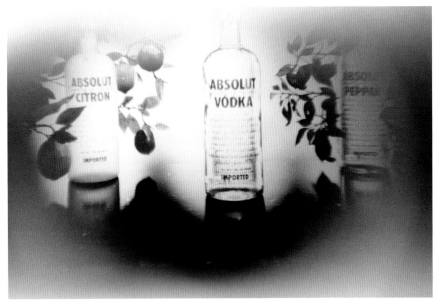

ABSOLUT VODKA

121. Absolut Vodka, Sweden, [ca. 1980s]. 8½ x 3¼".

Squeeze the bottle-shaped cardboard to round it out and cause the two embedded lenses to focus on the bottles of Absolut pictured inside.

122. Absolut Vodka, Sweden. *Absolut Smith Recipes/Flip Book*, 1996. 4 x 3½".

Flip the pages from one side of this booklet and the images pour out from a bottle of Absolut vodka. Flip from the other side to read cocktail recipes.

123. Absolut Vodka, Tel Aviv, Israel. *In an Absolut world, opportunities always pop up*, [ca. 2009]. 6 x 4".

Follow the directions in Hebrew in this promotional piece to punch out the heavy Absolut vodka "Pop up and Serve Mini Bar" box, the "תליבח תונפסא השדח תכפוהש תפכמל ינימ בר" [new collectible package that turns into a minibar]. Sold in limited editions, the packaging becomes a small garnish tray holding ice and munchies and a small bottle of Absolut.

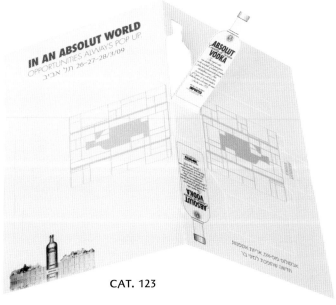

CAT. 124

124. Player's Navy Cut Cigarettes, England. *Smoke Players* [sic] *Navy Mixture*, [ca. 1900]. 9½ x 3".

A curious chromolithographed trade card showing a young boy climbing a tree only to find a pack of cigarettes.

125. The American Tobacco Company. *Herbert Tareyton: There's something about them you'll like*, 1939. 2½ x 1⅞".

In 1875, tobacco product manufacturers started to insert cards in order to stiffen the packaging. The cards began to be issued in sets in 1893. In every Tareyton cigarette pack sold in Britain in 1939, a pop-up card of an English landmark was inserted. Each card was enclosed in an illustrated envelope that described the history of the landmark. These premiums were produced in a set of twenty-four, encouraging smokers to collect the set. Shown here is Buckingham Palace.

CAT. 125

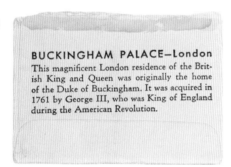 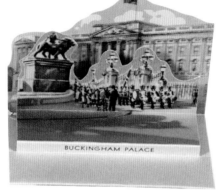 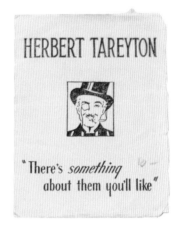

CAT. 126

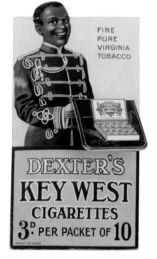

126. Dexter's Key West Cigarettes, [ca. 1940s]. 6⅛ x 3⅞ x 4½".

The young liveried man in this patented advertisement for English cigarettes reminds one of the bellhop Johnny, who "call[ed] for Phillip Morris" cigarettes when it was legal to advertise cigarettes on TV. Open the easel and a tray with the cigarette carton lifts up. In England and the United States, patents on the movable mechanisms were applied for. This ad was probably made for placement on tobacco shop counters.

127. The Seeburg Corp., Chicago, Ill. *Presenting the TOP profit maker in the history of cigarette vending*, [ca. 1960]. 11 x 17⅞ x 4½".

Seeburg's new vending machine promised more profit by prioritizing the "fastest moving brands," and accepting "three-way pricing." The v-fold pop-up in the paper folder demonstrates the machine sold by a Canadian vending machine distributor. The ad promises the machine has "more features that add to the profit of every pack sold."

CAT. 127

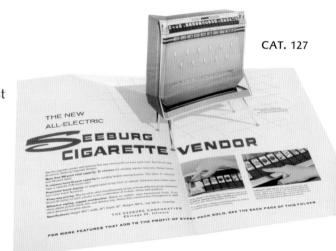

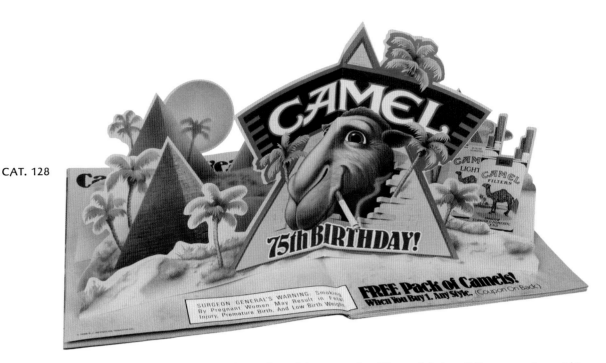

128. R. J. Reynolds Tobacco Co. *Camel. 75 Years and still smokin',* 1988. 11 x 16 x 7¾".

Pop-up inserts in magazines became popular in 1986 soon after a Transamerica ad appeared in *Time* magazine (cat. 85). This March 7, 1988 issue of *Sports Illustrated* includes an ad for Camel cigarettes with a Buy 1 Get, One Free coupon. Men's magazines were considered a perfect medium for cigarette ads.

129. Vector Tobacco Company, Mebane, N.C. *Quest Cigarettes, "Nicotine Free. Simple as 1, 2, 3",* 2003. 10½ x 12 x 7".

In an example of putting planned obsolescence to commercial use, this company produced cigarettes containing three levels of nicotine to help users lower their degree of dependency. But, curiously in the same ad, a warning on the rear of the package states that "This product is NOT intended for use in quitting smoking. Quest is for smokers seeking to reduce nicotine exposure only." The object was apparently to keep smokers smoking but with less nicotine intake.

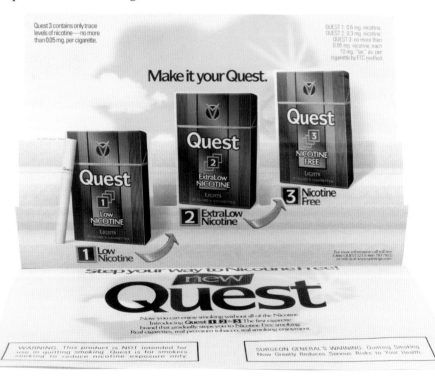

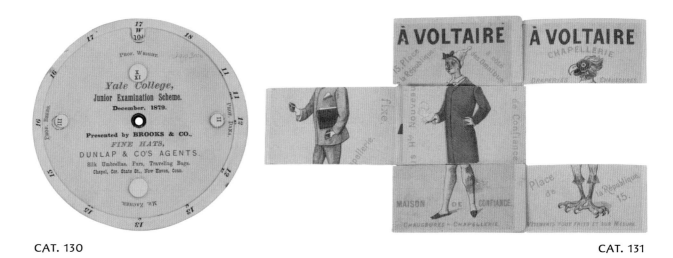

CAT. 130

CAT. 131

Fashion and Beauty

CLOTHING

130. Brooks & Co., New Haven, Conn. *Yale College, Junior Examination Scheme, December, 1879.* 4" dia.

This promotional volvelle giveaway informs the Yale College junior when his first semester final exams will be given by four professors. Brooks & Co. was a retailer of men's haberdashery and accessories located on campus.

131. À Voltaire, Paris, France. *Conféctions pour hommes jnes* [sic] *gens et enfants* [*Clothing for men, young people and children*], [ca. 1880]. 4⅞ x 8¾". M. P. H. Laas, printer, Paris and Marseille, France.

Mix and match the triptych, with three-way split flaps, to see men's fashions with animal heads and feet. This shop produced made-to-measure hats and clothes for the whole family. It is significant that "Prix Fixe" is printed on it since retail prices were always negotiable until set prices were instituted by Aristede Boucicaut of Au Bon Marché in 1852.

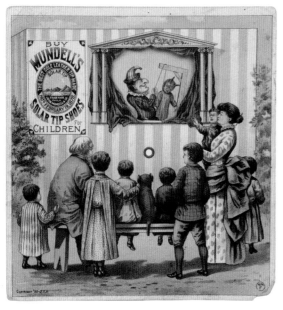

CAT. 132

132. John Mundell & Co., Philadelphia, Pa. *Buy Mundell's Solar Tip Shoes for Children,* [ca. 1888]. 7½ x 7⅜".

Behind the proscenium, turn this giveaway volvelle of a Harlequin play to see the different acts, some surprisingly violent with a gun and a hanging. The imagery reflects a different sensibility of the times when it comes to what's deemed appropriate for children.

133. *La Chemiserie Française* [*The French Shirt*], [ca. 1900]. 3⅞ x 3¾".

This card states "Trouseaux [sic] pour hommes Lingerie pour dames" [Clothes for men Lingerie for women] but only shows menswear in the illustration and on the volvelle that rotates under a die-cut window.

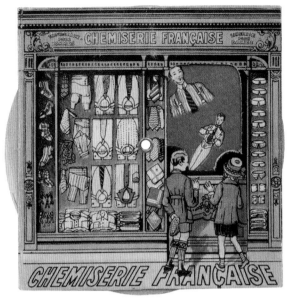

CAT. 133

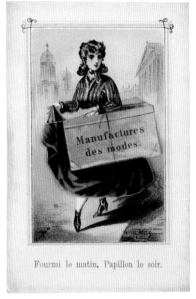

CAT. 134

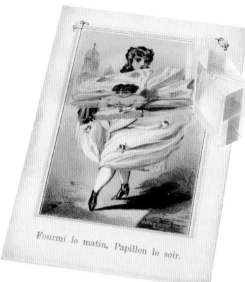

CAT. 135

134. Manufactures des modes, [Paris]. *Fourmi le matin, Papillon le soir* [*Ant in the morning, Butterfly in the evening*], [ca. 1900]. 4⅞ x 3⅞".

Lift the flap on this color-illustrated trade card for a French design firm and the woman changes from wearing daytime attire to one dressed in a flowing evening gown.

135. The B.V.D. Company. *Always Look for the Red "B.V.D." Label: "Next to myself I like 'B.V.D.' Best,"* 1926. 3⅝" dia.

Find a man's measurements through the die-cut holes on one side of the volvelle, then flip to the reverse for the proper Union Suit size to buy. The Union Suit is a one-piece underwear that originally featured a drop seat.

CAT. 136

136. D. H. Medias [D. H. Stocking Company, Spain]. *Las flores y las media son el verdadero, adorno para la mujer.* [*Flowers and stockings are the true ornament for women*], [ca. 1920s]. 3⅝ x 2⅝" (closed); 9½ x 6¾" (opened). Carlos Vives, illustrator.

Four-page string-bound booklet, with blank areas for notes, that unfolds layers of color illustrated flowers to show the seven hosiery colors available. Illustrator Carlos Veses (1900–74) is considered by some to be the first great graphic artist of the twentieth century.

CAT. 137

137. Les Magasins de la Belle Jardinière, Paris. *La Plus Grande Maison de Vêtements du Monde* [*The largest clothing store in the world*], [ca. 1920s]. 9½ x 6⅜". A. Norgeu, printer, Paris.

Cut out the color illustrated characters and place them in the designated slits in the background to create a diorama of the Parisian department store, Belle Jardinière, selling ready and tailor-made clothes.

138. The Sport, Paris. *Good Bye!*, [ca. 1920s]. 4⅜ x 4½". Chambrelent, printer, Paris.

When you open this trade card, the gentleman tips his Wallis hat, "the lightest in the world" ("Le Chapeau Wallis est toujours le plus léger du monde.") The image on the front has him saying, "Good Bye!" Perhaps with a company name like The Sport, it is operated by an Englishman. In French, with the curious English greeting.

CAT. 138

139. Levi Strauss Jeans, San Francisco, Calif. *Two Horse brand overalls are made for men of every trade*, [ca. 1930]. 7½ x 3¾" (closed), 22 x 7" (opened).

CAT. 139

Since Levi Strauss patented the riveted blue jean in 1873, the denim pants have remained an American icon. This folded ad looks like a pair of blue jeans, but when you see this advertisement opened, showing their many products, you know why it takes an origami artist to re-fold. Shown with an opened facsimile.

140. *Fashion and Figures.* New Haven, Conn.: Spencer, Inc., 1947. 24 pp., 13 x 7¾".

This book with linen-covered boards in a plastic comb binding promotes the wearing of girdles and bras for better posture and appearance. Contents include a page with a jointed female figure and a die-cut slot so that moving a grommeted disc changes the joints of her body, shoulder, waist, hip, knee and ankle, altering her posture. The type of resulting posture, lordotic, erect, or fatigued, is listed in the slot. Samples of the fabrics are included.

141. *Famous Hats from the Disney Hat Box.* New York: Disney Hats, [ca. 1940s]. 10 pp. 10½ x 26½".

In vintage baseball game footage, especially from the 1930s and '40s, every man can be seen wearing a hat. A well-dressed man wouldn't leave home without one. This over-sized hat box-shaped catalog has four pop-up hats "styled and tailored by Disney" on each page. Disney Hats was founded in 1885 as a retailer of men's hats in New York City, and after several ownership changes over the decades, the Disney Hat brand was acquired by the John B. Stetson Co. in 1960.

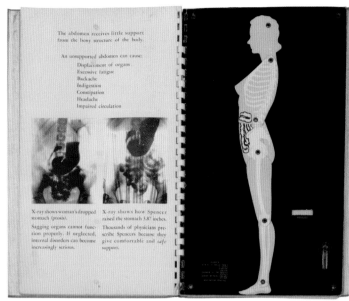

CAT. 140

CAT. 141

142. Sears, Roebuck and Co., *Sears 'Back-to-School' Adding Machine,* [ca. 1940s]. 4½ x 5¾".

Use the double-wheel volvelles as an adding machine to total up the savings by shopping at Sears. *"It's an old American Custom, first to Sears then to school."* The directions for use are hard to follow.

143. Shell Oil Co., New York. *Carol Lane's Vacation Dress-O-Graph: how to plan your travel wardrobe,* 1953. 16 pp., 7 x 10".

Turn the split pages to mix and match a woman's travel wardrobe according to Carol Lane, the women's trav-

CAT. 142

77

el director of Shell Oil Co. This booklet provides guidance on how not to overpack for a two-week vacation and on how to create different blouses by making and folding a stretch of triangular fabric.

144. Polox Glasses. *Potégez votre vue avec les lunettes anti-réverbération "Polox"* [*Protect your eyesight with the "Polox" anti-glare glasses*], [ca. 1960]. 4½ x 6½".

Czech paper engineer, graphic designer, and illustrator Vojtěch Kubašta created many consumer product advertisements using pop-ups and movables. Although working in a Communist Czechoslovakia, exporting manufactured goods was a priority for its economy.

145. *The Secret of Richard Grand 100% Cashmere.* Paris: Richard Grand, 2002. 14 pp., 9¾ x 18¼". Rossana Papagni, Milan, paper engineer; Patrizia La Porta, illustrator; Alja, printer, Slovakia.

Richard Grand contacted the present owner of this collection, The Popuplady, looking for assistance in locating pop-up book assembly plants in North America. In gratitude, Grand sent me his promotional catalog of the cashmere sweaters he manufactures in Asia. Each pop-up model is wearing one of those sweaters. The catalog also tells the story of a prince who wins the princess by giving her a cashmere sweater. In English, German, and French.

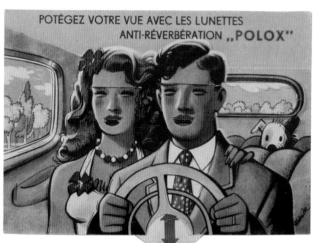

CAT. 144

CAT. 145

146. Cartier, New York. *You are cordially invited to . . .* , 2017. 5⅞ x 8¼.

So confident in their brand name, there is minimal text on this heavy promotional pop up invitation to their *haute joaillerie* [fine jewelry] exhibit.

147. Pierre-Alexis Dumas. *Hermès Pop-up.* [Paris]: Actes Sud/ Hermès, 2018. 24 pp., 8½ x 8½". Bernard Duisit, paper engineer; Charles Penwarden, translator.

Each of twelve Hermès scarves have their designs animated with several different page-activated mechanicals, including pop-ups, a volvelle, transformation, and diorama. In English from the French.

148. L. Leichner, Berlin, Germany, *Parfumerie théatrale Poudre grasse: blanche [Theatrical make-up, Grease Paint: white]*, [ca. 1890]. 3¾" dia. Heyman & Schmidt, printer, Berlin.

The L. Leichner company, started by a former opera singer, produced and sold theatrical makeup, including this grease paint for performers. The chromolithographed advertisement, resembling a compact, opens to the pop-up likeness of Adelina Patti (1843–1919), a renowned Italian opera singer.

149. Lever Brothers, UK. *The Old Way, The Sunlight Way*, [ca. 1890]. 6½ x 3½".

Starting out as the Old Way, we see a sweating bent-over woman scrubbing clothes by candlelight in the evening. Then pull the tab and she's sitting reading a book at 11 AM with the wash already on the clothesline–The Sunlight Way. The image lists the tasks a woman no longer has to do: "No Boiling, Toiling, Rubbing, Scrubbing." The effective graphics clearly communicate the message.

CAT. 146

CAT. 147

CAT. 148

CAT. 149

79

150. J. Gosnell & Co., Ltd, London and Paris. *The "Famora" Dressing Table*, [ca. 1899]. 5 x 6 x 1½".

CAT. 151

CAT. 152

To place the Famora products (soap, perfume, and powder) on the dressing table, punch out along the perforations. The table will rise, and the woman will mimic the Famora Lady in the mirror. "Ask your chemist for other advertising novelties."

151. Le Pétrole Hahn, France [Hahn Hair Oil]. *Le Pétrole Hahn au Cinéma* [*Hahn Oil in the Movies*], [ca. 1920s]. 5⅞ x 7".

Cut out the peepshow viewer, the characters, and the volvelle and have the wheel rotate around a matchstick to see the product and a woman's face go from sad to happy after applying Hahn Oil. This DIY advertisement has product testimonials on the reverse.

152. *S.28 Véritable lait de beauté* [*Real beauty milk*]. Paris, [ca. 1920s]. 3⅛ x 6⅛ x 3".

Attached to one side of the box for the French soap S.28 is a pop-up illustration of children bathing. An unusual survival, given the product's handling and use.

153. DuBarry. *Symbol of Beauty: The Power of Beauty-The Art of Make-up*, [ca. 1930]. 7¼ x 13¾".

The fan is a perfectly fitting device to use to promote beauty products. In this case, the double-sided eight-panel fan has each blade showing the correct makeup to use for each woman's hair color. Using these suggestions, women may aspire to the spectacular beauty of Lady DuBarry (1743–93), but hopefully won't be guillotined as she was. Richard Hudnut (1855–1928) was the founder in America of the DuBarry makeup brand.

154. Urban Decay Cosmetics, Newport Beach, Calif. *Urban Decay: Disney Alice in Wonderland*, 2010 5½ x 10½ x 6".

Each cosmetic eyeshadow in the box is given a name "inspired by" Tim Burton's live action *Alice in Wonderland* movie as Alice walks through the mushroom forest. There are sixteen square palettes, two eyeshadow pencils, and an eyeshadow tube shaped like a chess pawn, all in a ribbon-pulled drawer. The top lid, stamped with gold-foil text, lifts to uncover pop-ups of the mushroom forest and Alice. A mirror in the lid creates a vanity table effect. A card labeled *Book of Shadows, Palette de Fard à Paupières* in the plastic protective sleeve gives the ingredients of the eyeshadow, images of the palettes, and name explanations.

CAT. 154

CAT. 153

155. *Lancôme Show by Albert Elbaz.* Paris: Lancôme, 2013. 8 pp., 10 x 12". Kyle Olmon, paper engineer; Albert Elbaz, illustrator.

This color-illustrated pop-up book, cum elaborate press release, incorporates several different mechanicals that highlight the collaboration between cosmetics company Lancôme and fashion designer Albert Elbaz. There is a DVD held by a rubber snap on the endpaper. The pop-up centerfold—a double-page spread of a stage set with a pop-up audience and bride and groom up the aisle—was also included as an insert in *Vogue's* July 2013 Fall Fashion issue.

CAT. 155

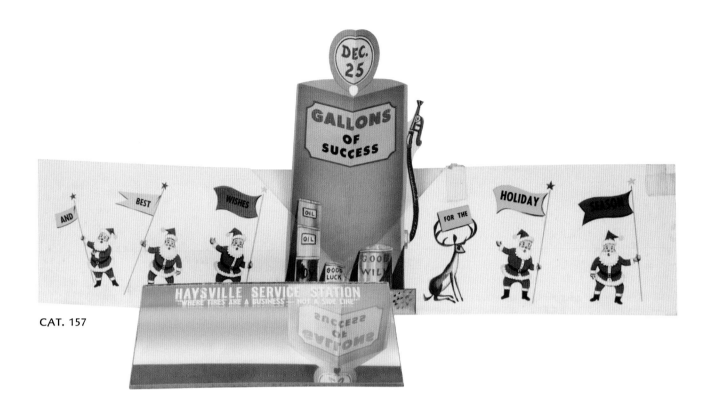

CAT. 157

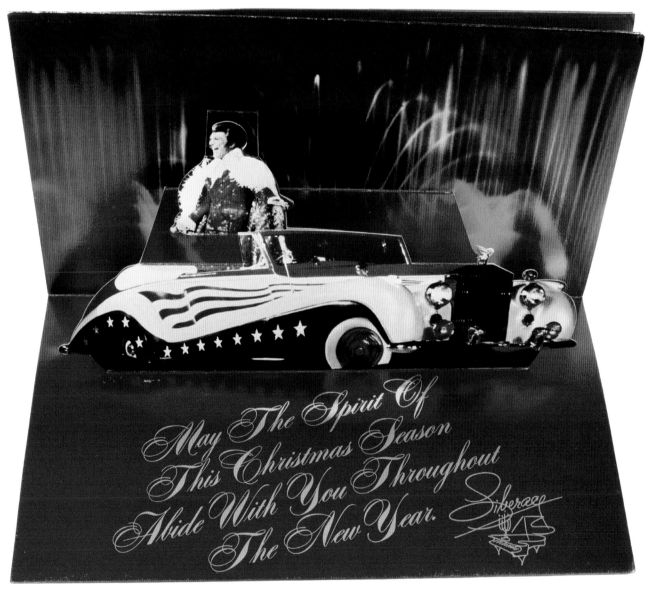

CAT. 161

Holidays

156. *Christmas Tree Grove . . . space for store ad*, 1936. 7¼" dia.

This is one of those rare volvelles that combines the benefits of the volvelle with the slice book format. Each of the three tabs on the periphery turns a wheel which shows either a head, torso, or legs. Combine them to create a fantastical character through the die-cut window. This colorful Christmas-themed volvelle is intended to be given as a promotion by the business whose name would be printed on the space provided.

157. Haysville Service Station, [Kansas]. *Where tires are a business–Not a side line*, [ca. 1940]. 7½ x 16½".

This colorful pop-up advertisement and Christmas card gave the recipient a mirror tucked into a folder. The gas station's name and slogan were printed on the mirror. I assume the card, with a breakable promo, was hand-delivered to customers and not put into the mail.

158. Magic Christmas Gift Selector. *Come with me on a Shopping Trip through . . .*, [ca. 1950]. 8⅞" dia. Gordon K. and Sam Gold, creators.

This double-sided volvelle is a prototype for a department store to help customers make their Christmas gift selections. Gibberish letters or marks are where the store could put their name or logo. The die-cut hole on one side lists the merchandise that can be found on each floor. The reverse would give the store's hours and related information and gift suggestions, based on family relationships, like mother, sister, or aunt, through die-cut holes. This prototype is from the archive of its designers, Gordon K. and Sam Gold, one of the most creative and prolific producers of advertising premiums in the United States from 1920 through the 1980s.

159. Barricini [chocolates]. *Whoever elaborates in retelling the story of the Exodus, is praiseworthy*, 1958. 19 x 3¾".

Barricini candies are Kosher for Passover, and with this promotional sleeve, the order of the Seder is shown one-by-one through the die-cut hole when the inner card is pulled up. The meaning of the Passover symbols is shown on the reverse.

160. Washington Heights Federal Savings and Loan Assoc., New York. *Seder-ama: The Picture Seder Guide*, [ca. 1960]. 6½" dia.

The Passover Haggadah, meaning "order", is essential to the Seder, the ritual dinner that commemorates the freeing of the Jews from Egyptian bondage. The Haggadah instructs the congregants specifically how to conduct the dinner. The colorful volvelle gives fifteen steps of the Seder in the die-cut holes, with an abbreviated explanation of the holiday symbols and story of Exodus on the reverse. In English and Hebrew.

CAT. 156

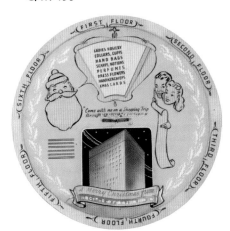
CAT. 158

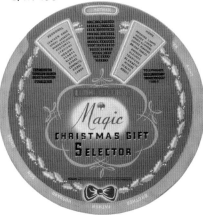

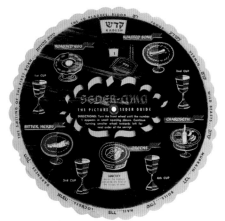

CAT. 159

CAT. 160

161. Liberace, Las Vegas, Nev. *Merry Christmas 1976.* 5¾ x 9 x 2″.

Reflecting Liberace's famed flamboyancy, his red and sparkly Christmas card features a feathered pop-up Liberace and his 1954 Park-Ward Rolls-Royce at the Las Vegas Hilton. It's a self-promotion for his fans.

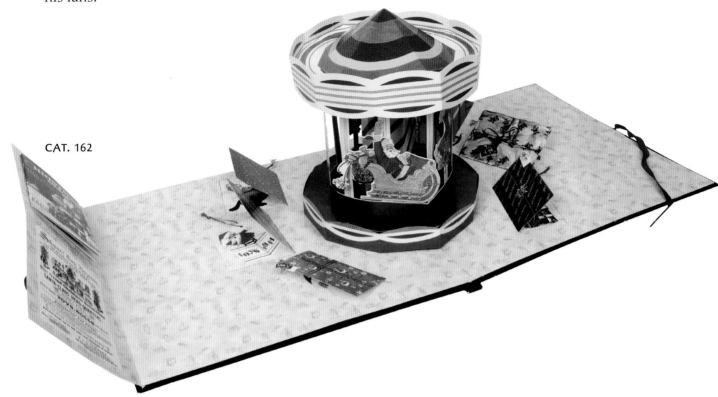

CAT. 162

162. F. A. O. Schwarz, New York. *F. A. O. Holiday Collection 1920–1948: A Pop-up Treasury, 1997.* 11 x 11¼″.

Exclusively designed for the store by paper engineer Ron van der Meer, this keepsake presents removable tree ornaments reflecting Schwarz's catalog covers of years past and a history of Santa and the famous toy store. The center has a magnificent carousel.

163. Pier 1 Imports. *Holiday Decorating 2015: Limited Edition,* 2015. 8pp., 10½ x 7½″. Bruce Foster, paper engineer.

Product catalogs are ephemeral, made to be tossed when done. Some will discard them without looking at them at all. Pier 1's 2015 holiday catalog with five pop-ups surely got at least one look through.

164. Jewish Federation of Greater Houston, Houston, Texas. *May your candles shine brightly to erase the darkness in the world: Happy Chanukah.* 2018. 9¼ x 11¼ x 5½″. Bruce Foster, paper engineer.

Chanukah, the Festival of Lights, is brightly symbolized with the fully lit menorah. The Jewish Federation, with divisions all over the United States, provides support for Jewish and humane causes. This is probably a "thank you" card given to volunteers and donors.

CAT. 163

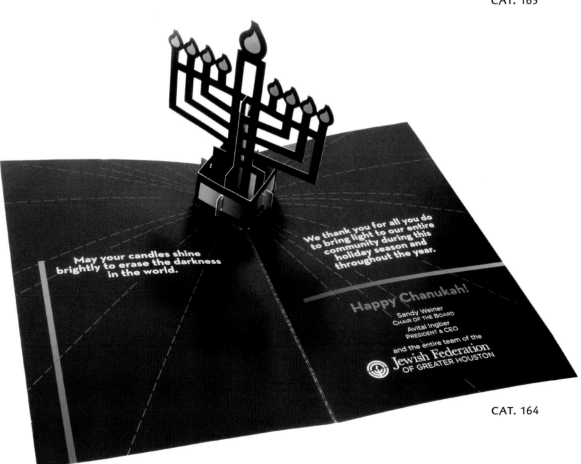

CAT. 164

3-D (three-dimensional): An illustration or other artwork that stands perpendicular to the flat page. It may be activated when the previous page is turned or by a pull mechanism like a string, ribbon, or tab (cat. 198).

tirette: The French term directing the user to pull a strip of paper or tab which activates a movable. "Tirette" may also be printed directly on the tab.

trade card: Either a standard business card (2 x 3½") (cat. 104} or larger (cat. 59) with text of a company or entrpreneur's contact information, logo, and sometimes a slogan, to be given to prospective clients.

transformation: Two illustrations are slit like Venetian blinds vertically or horizontally and assembled one on top of the other. When pulled by a tab, the top illustration will slide over or interweave with the one beneath. The bottom illustration will become the top one. Sometimes, this device will be called a metamorphic (cat. 33).

triptych: A folder or pamphlet that has three panels when opened (cat. 47).

tunnel book: A series of die-cut shaped illustrations arranged one behind the other to form a tableau. They are supported by side or top panels. The front cover has one or more die-cut openings to allow viewing of the illustrations. The effect creates a sense of depth, as in looking into a tunnel. Also called a peepshow, the term is derived from eighteenth- and nineteenth-century itinerant showmen who carried these layered tableaus in boxes and charged a fee for viewing (cat. 177).

turn-up book: The first movable book for children (ca.1770), and created by Robert Sayer, is a folded pamphlet with illustrations and text split in the center and affixed to another illustrated page. When the split illustration is turned up or down, the graphic on the base page changes and moves the storyline along. The Harlequin character often appeared in these early turn-up books, which were alternatively called Harlequinades. (see Harlequinade) (cat. 32).

v-fold: A basic movable device, created by making an angular cut onto folded paper, that pops up from the gutter of a book or card when it is opened (cat. 77, 85).

volvelle: Wheels of paper placed one on top of the other that rotate around a central axis and are secured by a central string, paper grommet or rivet. Information on the base page is collated by a pointer on the wheel's edge or through die-cut holes in the circle. The term volvelle is derived from the Latin verb *volvere*, to turn. Volvelles were first used in the thirteenth century and are considered the first analog computers (cat. 21, 158).

waterfall: Pull a tab on the base page and a series of illustrations will cascade, one following the other (cat. 165).

wheel: An illustrated disc of paper or cardstock sandwiched between two adjoining pages and secured by a paper disc or metal grommet. Die-cut holes in the top page allow for the illustrations drawn around the wheel to show through the holes (cat. 22). Wheels are considered volvelles (cat. 67).

Selected Bibliography

AdAge Encyclopedia. "History: Pre-19th Century." September 15, 2003. http://bitly.ws/rYKn.

Adams, Peter. "Office Building Pops Up in Time." *Orlando Sentinel* (September 6, 1986). http://bitly.ws/rYKA.

Akcigit, Ufuk, John Grigsby, and Tom Nicholas. "When America Was Most Innovative, and Why." *Harvard Business Review* (March 6, 2017). http://bitly.ws/rYKJ.

Aldrich-Runzel, Nancy, ed. "Paper Designs That Pop: Follow paper engineers at Structural Graphics as they create a clipper ship insert." *Step-by-Step Graphics Magazine,* vol. 2, no. 5 (Sept/Oct). Essex CT: Structural Graphics, 1986.

Altered Steel. "Helene Rother: A Trailblazer in the Automotive Design." *Altered Steel,* March 30, 2021. http://bitly.ws/rYLn.

Altered Steel. "History of Car Advertising," *Altered Steel,* March 18, 2021. http://bitly.ws/rYLd.

Automotive Hall of Fame. "Helen Rother (1908–1999), Inducted 2020/2021." 2022. http://bitly.ws/rYKQ.

Baer, Drake, Ivan De Luce, and Richard Feloni. "17 Iconic Ad Campaigns That Changed the World." *The Business Insider,* updated July 2, 2019. http://bitly.ws/rYKV.

Barker, Hannah. "Medical Advertising and Trust in Late Georgian England." *Urban History* 36, no. 3 (2009): [379]–98. (Cambridge: Cambridge University Press). http://bitly.ws/rYL3.

Blake, N. F. *William Caxton and English Literary Culture.* Wallingford, UK: A & C Black, 1991.

Boyle, PhD, Eric W. "Quackery and the Civil War." *National Museum of Civil War Medicine.* May 11, 2017. http://bitly.ws/rYMQ.

Breskin, Charles A. "Premiums in Plastic." *Scientific American* 174, no. 4 (April 1946): 158–60.

British Library: Collection Items, "Advertisement for Beecham's Pills." Accessed April 10, 2020. http://bitly.ws/se8p.

Cartolino.com. *The Trade Cards of the "Au Bon Marché" Collection.* October 20, 2014. http://bitly.ws/rYL8.

Casey, Ryan. "What is the History of Business Cards?" *Casey Printing,* September 1, 2017. http://bitly.ws/se84.

Chapp, Belena S. and Martha Carothers. *A Surprise Inside! The Work and Wizardry of John Walworth: Catalog of the Exhibition at the University of Delaware.* Newark, DE: University of Delaware, 1989.

Crouse, Megan Corinn. "Business Revolution: The Ad Agency." Fall 2010. http://bitly.ws/rYLc.

Dyhouse, Carol. "Working-Class Mothers and Infant Mortality in England, 1895–1914." *Journal of Social History* 12, no. 2 (Winter 1978). https://bit.ly/3QoJx6M.

Flanders, Judith. "Victorian Christmas." *British Library: Discovering Literature: Romantics & Victorians.* May 14, 2014. http://bitly.ws/rYLg.

Fowler, Jr., Nathaniel C. *Fowler's Publicity: An Encyclopedia of Advertising and Printing, and All That Pertains to the Public-Seeing Side of Business.* (New York: Publicity Publishing, 1897), 55–56. http://bitly.ws/se7Q.

Friedman, Dr. Dan. *The Birth and Development of American Postcards: A History, Catalog and Price Guide to U. S. Pioneer Postcards.* West. Nyack, NY: Classic Postcards Press, 2003.

Golembeski, Dean. "Pop-up Creations a Startling Success for Advertising Firm." *Washington Post* (January 3, 1989).

Greene, Stephen L. W. and Sammy R. Danna, eds. *Advertising and Popular Culture: Studies in Variety and Versatility*. Bowling Green, OH: Bowling Green State University Popular Press, 1991.

Harvard Business School. *The Art of American Advertising: Souvenirs & Novelties.* Boston: Baker Library Historical Collections. http://bitly.ws/rYLq.

Heller, Steven and Steven Guarnaccia. *Designing for Children: The Art of Graphic Design in. . . .* New York: Watson Guptill. 1994.

The Hooded Hooligan. "The Cookie Quest Chronicles." *Herbert C. Hoover: America's "Napoleon of Mercy."* May 24, 2010. http://bitly.ws/rYLu.

Kirsch, Francine. *Chromos: A Guide to Paper Collectibles.* La Jolla, CA: A. S. Barnes, 1981.

Klass, Perri. "Introduction: The Waning of Child Mortality and the New Expectations of Parenthood." *A Good Time to Be Born: How Science and Public Health Gave Children a Future.* New York: W. W. Norton, 2020.

Lambert, Julie Anne, Michael Twyman, Lynda Mugglestone, Helen Clifford, Ashley Jackson, and David Tomkins. *The Art of Advertising.* Oxford: Bodleian Library, 2020.

Lee, MPH, Benita. "How Is Consumer Drug Advertising Regulated in the United States?" *GoodRx-Health*, updated June 16, 2019. http://bitly.ws/rYLB.

Lorenzi, Neal. "Making a Profit with: Specialty Printing." *American Printer* (September 1985).

Maguire, Mike. "From 3-D to Pop-ups: Go Dimensional." *PharmExec.com.* http://bitly.ws/rYLF.

McBride, Hannah. "Postcard History." *Nowhere: People/Place/Time*, 2015. http://bitly.ws/se8W.

Miller, Michael B. *The Bon Marché: Bourgeois Culture and the Department Store 1869–1920.* Princeton, NJ: Princeton University Press, 1981.

Mowat, Jon. "A Brief History of Automotive Marketing." *PrintMag,* November 18, 2015. http://bitly.ws/rYLH.

Nagle, James J. "Trading Stamps: A Long History." Sec. F, p. 7. *New York Times* (December 26, 1971). http://bitly.ws/rYLK.

Nestle.com. "Nestlé: Good Food Good Life." *The Nestlé Company History.* http://bitly.ws/rYLR.

Norman, Jeremy. "Exploring the History of Information and Media through Timelines." *Caxton Prints the First Book Advertisement in the English Language, 1476–1477.* HistoryofInformation.com. http://bitly.ws/rYLy.

O'Loughlin, Sandra. "How Alcohol Brands Are Adding Flavor to Their Events." *Event Marketer*, December 27, 2016. http://bitly.ws/se8i.

Olver, Lynne, ed. "FAQs: Baby Food." January 3, 2015, FoodTimeline Library. http://bitly.ws/rYLm.

"Pandora—or What Happened Before Vogue." *Hidden Wardrobe*, July 3, 2013. http://bitly.ws/rYLs.

Powell, Alvin. "Specialty Firm Hopes Pop-ups Shed Gimmick Image." *Across the Board.* New York, June 24, 1988.

Pozzi, Lucia and Diego Ramiro Fariñas. "Infant and Child Mortality in the Past." *Annales de Démographie Historique*, no. 129 (2015).

Quick, Tyson. "Advertising Evolution: How Personalization Has Improved Over Time," updated June 11, 2021. *Instapage.com.* http://bitly.ws/rYLV.

Rebsamen, Werner. "Pop-ups." *American Printer* (September 1988).

Rieger, Loretta Metzger and Lagretta Metzger Bajorek. *Children's Paper Premiums in American Advertising 1890–1990s*. Atglen, PA: Schiffer Publishing, 2000.

"Sam Gold, Premium King: The Premium History of Sam and Gordon Gold, Good as Gold. . . ." http://bitly.ws/rYM3.

Scoop. "Sam and Gordon Gold Premiums in Hake's Auction #221." [2017]. http://bitly.ws/rYM5.

Scoop. "The Premium History of Sam and Gordon Gold." Accessed May 2, 2021. http://bitly.ws/rYM7.

Share, Bernard. "Pasteboard Perceptions." *History/Ireland,* Features, issue 2, vol. 10 (Summer 2002). http://bitly.ws/rYMb.

Shopland, Donald R., ed. "Risks Associated with Smoking Cigarettes with Low Machine-Measured Yields of Tar and Nicotine," *National Institute of Health, Smoking and Tobacco Control Monograph 13* (November 19, 2001). http://bitly.ws/se8b.

Smith, William. *Advertise: How? When? Where?* London: Routledge, Warne, and Routledge, 1863. Reprint, Whitefish, MT: Kessinger Publishing, 2015.

Sorisi, Guiseppe and Silvio Bruno. *Catalogue Chromos au Bon Marché*, 4th ed. Milano, Italy: Sorisi, 2009.

Stevenson, Heon. *American Automobile Advertising, 1930–1980: An Illustrated History.* Jefferson, NC: McFarland, 2008. http://bitly.ws/rYMf.

Structural Graphics LLC, Essex, CT. "Hand Assembly." Accessed April 9, 2020. http://bitly.ws/rYMj.

Swanson, "Why the Industrial Revolution Didn't Happen in China." *Washington Post* (October 28, 2016). http://bitly.ws/se7q.

Tungate, Mark. "Pioneers of Persuasion." *Adland: A Global History of Advertising* (pdf).

United States Postal Service. "Postage Rates for Periodicals: A Narrative History." June 2010. http://bitly.ws/se8J.

Voon, Claire. "The False Advertising of Sophistically Decorated, 19th-Century Pharmaceutical Trade Cards." July 4, 2017. *Hyperallergenic.com.* http://bitly.ws/rYMp.

Walker, Cameron. "Selling Style I: The History of Fashion Marketing Through the 19th Century." *Wilson College News,* Wilson College of Textiles, NC State University. May 24, 2019. http://bitly.ws/rWXs.

Wikipedia. "Nash Rambler." Accessed July 17, 2021. http://bitly.ws/se7F.

Wikipedia. "Premium (marketing)." Accessed March 17, 2020. http://bitly.ws/rYMu.

Wikipedia. "Radio premium." Accessed March 17, 2020. http://bitly.ws/rYMx.

Wikipedia, *History of Advertising.* Accessed March 19, 2020. http://bitly.ws/rYMJ.

Wollenberg, Skip. "Joe Camel Ticket Ad Under Fire." *SouthCoastToday/The Standard Times* (March 20,1996). http://bitly.ws/rYMB.

Yates, Robin D. S. [interviewee]. "Ancient Worlds: China's Age of Invention." NOVA, February 29, 2000. http://bitly.ws/rYMN.

Index of Names

(Numbers in **bold face** refer to a page number;
all other numbers refer to catalog entries.)

Index of Mechanical Devices

(Numbers refer to catalog entries.)